START CALLIGRAPHY
THE RIGHT WAY TO WRITE

In the same series

The Right Way To Draw
The Right Way To Draw Landscapes
The Right Way To Draw People
The Right Way To Draw Animals
The Right Way To Draw Cartoons

Uniform with this book

START CALLIGRAPHY

THE RIGHT WAY
TO WRITE

Jon Gibbs

RIGHT WAY

Set in 11/12pt Times by County Typesetters, Margate, Kent.
Printed and bound in Great Britain by Cox & Wyman Ltd., Reading, Berkshire.

The *Right Way* series is published by Elliot Right Way Books, Brighton Road, Lower Kingswood, Tadworth, Surrey, KT20 6TD, U.K. For information about our company and the other books we publish, visit our web site at *www.right-way.co.uk*

*Dedicated
to the memory of the late
Maurice Percival ARCA,
who introduced me to this
fascinating craft,
and to
Ann Hechle,
who taught me so well
how to do it.*

CONTENTS

1

WHAT IS CALLIGRAPHY?

This is a book for beginners. It is written by a teacher who has taught beginners with all levels of ability over the past twenty years. The method is tried and tested; it will work for you if you work at it – try it; and above all enjoy it.

Joining your local calligraphy group will put you in touch with other enthusiasts; enable you to take part in workshops, classes and competitions; and inform you of the world of calligraphy (see Appendix of useful addresses).

If you are really keen to become professionally qualified later on, there are a small number of full time courses which are essential to gain the highest levels of skill necessary.

Writing with alphabetic symbols (as opposed to communicating with pictures which preceded it) is one of the most significant advances in the process of civilisation. Calligraphy has been part of that process for roughly 5,000 years.

Calligraphy as an art form has become clearly apparent in the past two decades. You can be a traditionalist or a 'trendy'; the choice is yours. Edward Johnston, who revived the craft of calligraphy in the early part of the twentieth century, during his teaching at the Royal College of Art in London, refined his beliefs into one sentence: *'Our aim should be to make good letters, and arrange them well'*. This book is designed to enable you to do just that. Go for it!

Go back to the Greek words from which the term is derived and you find that the word Calligraphy literally means 'beautiful writing'. At different times it has meant a variety of more specific things. Alfred Fairbank, who helped revive the art of

italic handwriting, used the description 'handwriting considered as art'; whereas Stanley Morison in the Encyclopaedia Britannica took something like 28 pages to describe and define it. For the purposes of this book I will define it as *'any form of writing and lettering that is done with care and consideration, and the intention to create a piece of work that will bring enjoyment to both the writer and viewer'*. I deliberately do not use the word 'reader' as a great deal of the more creative and artistic work that is done today is not meant to be read in the sense that might be applied to a book but more to be viewed just as one looks at a picture.

Getting Started

Life is a holistic activity; we do not learn to be walkers, talkers, eaters and drinkers as entirely separate processes. By doing everything on a daily basis we develop all aspects in a gradual way. Each day we get better at everything, little by little. A small child will eat, drink, walk and talk all at the same time!

The reasons I stress this 'all-at-once approach' are twofold: firstly, practising is tedious and, as Edward Johnston famously remarked, *'practising makes you good at practising'*; secondly, making 'things' is creative and exciting, and making things [finished pieces of calligraphy] makes you better at making things.

After the preliminary exercises which deal with the fundamentals of broad pen calligraphy, such as pen angle, weight and size, each chapter will introduce a new alphabet and/or materials and will culminate in a finished piece of calligraphy.

Preparing Your Drawing Board

To do anything well you must be comfortable, relaxed and safe. The term 'writer's cramp' must have originated from the days when all books were handwritten; imagine writing a whole book sitting at a table which is the wrong height, on a chair which leaves your legs dangling in space or your body hunched up, trying to see what you are doing in bad light, etc.

You need a chair which supports your lower back and allows

your feet to rest on the floor. The table should be suitable for your height and, ideally, you should work on a surface at an angle to the horizontal of about 30–40 degrees. This will allow you to work without being hunched over the table, see **fig 1**.

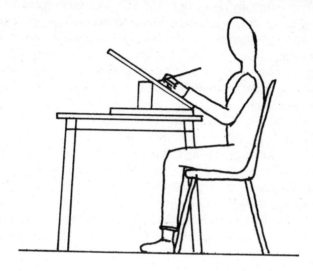

Fig 1. Comfortable posture.

The golden rule is 'if it hurts it isn't right'; if so change it. You cannot write for any length of time without getting cramp or backache if you are not sitting properly and comfortably; generally speaking, this means keeping your back as straight and upright as possible, and not twisting your upper body. If the natural light is inadequate you must use a table lamp; an adjustable one of the 'anglepoise' type is ideal.

It is possible to spend a lot of money on draughting equipment. It may look good and some of the facilities, such as parallel motion trammels, certainly speed up the task of drawing lines. However, calligraphy is essentially a low tech activity.

You can buy an A2 size drawing board with a mechanism for adjusting the angle. My one is hinged onto another piece of

12mm plywood and then propped up at the required angle with an empty pickle jar! In this way the angle is infinitely adjustable to ensure that the flow of ink or gouache in the pen is controlled to suit the work in hand, see **fig 3**.

Ink is generally quite thin and the pen itself needs to be almost horizontal in use, which necessitates having the board at an angle of about 45 degrees. However, gouache, and some other materials, are normally thicker and less free flowing; and they need the aid of gravity to make them work well, which means the board should be much flatter and perhaps even almost horizontal.

When the board is at an angle the paper is held in place and protected by a guard, placed across the board at a comfortable height for writing, see **fig 2**. This guard is simply a piece of paper which covers the lower part of the board, held in place by masking tape or draughtsman's clips. It is there to protect the writing surface from the grease which is naturally present in the skin of your hands. As each line of writing is completed, you slide the paper up from underneath the guard to expose the next line. If you first cover your drawing board with blotting

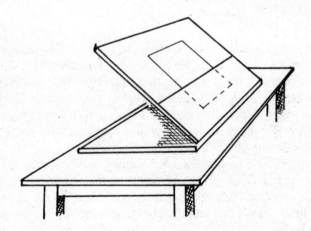

Fig 2. Hinged drawing board with guard across bottom part to protect writing surface.

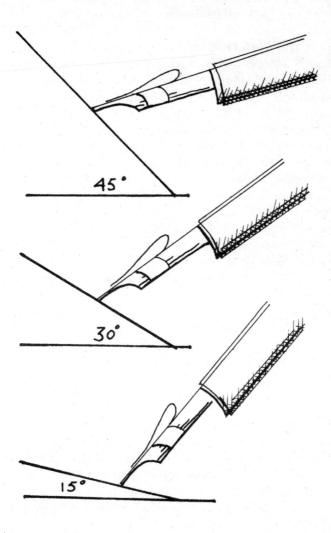

Fig 3. 45° normal angle for writing with ink.
 30° flatter when using gouache.
 15° almost flat for thick liquids such as mordants for gilding.

paper, or several sheets of cheap sugar paper, it will provide a softer, more sympathetic surface on which to write.

Tools and Materials

There is a plethora of pens, papers and inks on the market; all are described as the answer to all your needs. The finest calligraphy of the past was done with hand-cut quills, on hand-prepared parchment and vellum, using hand-made inks. The finest work today is done in exactly the same manner but a good deal of experience and skill is needed to prepare the tools and materials, so it is better to start with ready made items of a suitable quality.

Paper

You will need a pad of good quality cartridge paper for your initial attempts at finished work. A3 size (420 x 297mm) of about 100gsm (grams per square metre) weight is most suitable. For trials and 'roughs', detail or layout paper of about 50gsm is translucent enough for tracing and yet takes ink well enough.

Inks

NON waterproof Indian ink may be bought ready made. It must not be the waterproof type as this contains shellac resin which clogs the pen and makes writing impossible. I cannot stress the importance of this too much as it is the commonest mistake which beginners make when buying their gear. If you wish to be really traditional you can make your own ink by rubbing a stick of 'Chinese ink' in an ink stone partly filled with (preferably distilled) water. This method allows for adjustment of the thickness of the ink, and is ultimately better and cheaper. Waterproof ink is best reserved for brush painted work done for reproduction.

Coloured inks, even those with 'calligraphy' on the label, are an acquired taste and are best left till later in your calligraphic life. Most coloured calligraphy is carried out with diluted 'designer's gouache' tube colours available in a very

wide range of inter-mixable colours from all good art shops.

Pens
There is only one type of pen suitable for good, crisp, sharp-edged writing and that is the 'dip pen' as it is known. The dip pen has a metal nib with a reservoir to hold the ink, in a wood or plastic handle. Fountain pens and felt pens are convenient for children to use, for your own initial practising, and for portability when travelling, etc; but are inevitably cast aside for the real thing.

Most presentation packs of dip pens have a grave failing; they normally have only one pen holder. Ideally you will have as many holders as nib sizes, to avoid having to change nibs over during writing. There are several brands of dip pen available. None is best; they vary a little and, after initially trying different ones, you will settle on the type that suits your technique.

Mitchell Round Hand – available with nibs sized 0 to 6 (largest to smallest). These have a detachable reservoir which fits underneath the nib. This can be adjusted to control the flow of the ink. These British made nibs are to be found in most art shops and stationers.

Brause – come in nine metric sizes 0.5 to 5mm. These are made in Germany and each nib has a fixed reservoir on top of the nib. They are somewhat stiff but will stand up to heavy handed use if you tend to press rather hard.

Speedball – available in a range of sizes up to 0.5 inches. These American made nibs have fixed reservoirs on both top and underside. They are rather long and flexible with multiple slits in the larger sizes, which gives a very free ink flow; and they are very responsive to changes in pressure, see **fig 4**.

Right handers use nibs that are cut square ended; whereas left handers have an angled or oblique end to the nib which is specially for their use. Remember to ask for the right type. (See also Bibliography, page 217.)

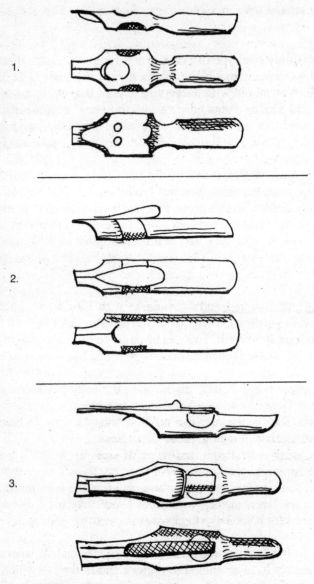

Fig 4. 1. Mitchell with reservoir underneath.
 2. Brause with top reservoir.
 3. Speedball has them top and under.

When starting any alphabet it is better to work quite large and a tool which fits the bill perfectly is the 'twin pencil', see **fig 5**. This tool replicates the corners of a metal nib by drawing the edges of the letter in outline form which enables the scribe to see, in the clearest possible way, how the letters are constructed. To make this tool, take two HB grade pencils and join them together by wrapping them in a tight paper tube. This tube facilitates sharpening the pencils and also adjusting their position. Right handed scribes should have their pencils level at the tip; left-handers with an oblique angle, see **fig 5**.

Some Fundamentals

Before starting to write letters there are a number of fundamentals that must be understood. Our alphabet has evolved over the centuries by being written by right handed people. When a square edged pen is held by a right handed person, the pen will naturally have a slanted 'pen angle'. It is essential thoroughly to understand the meaning of this term, and its effect on the appearance of letters.

Pen Angle has two interacting parts: primarily it refers to *the angle formed on the paper between the baseline of the writing and the thin line formed when the pen nib is slid along its edge*. Notice how when the pen is pulled at right angles to this thin line it will make its thickest stroke width, see **fig 6**.

This contrast between the thick and thin strokes is fundamental to the true character of broad pen calligraphy; and the exploitation of it is what makes calligraphy such an exciting visual phenomenon.

The secondary, separately variable but integral, component is the angle formed by the whole pen in relation to the surface; in other words the uprightness of the pen. This varies considerably from person to person, as will the manner in which the pen is held in the hand. This habit usually has been formed at an early age at primary school and, so long as you can write comfortably, individual differences are not crucial. It is also true that the angle at which the nib is cut (i.e. the tip of the nib)

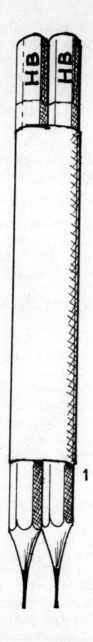
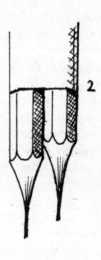

Fig 5.

1. Twin pencils in a tube made with paper and masking tape.
2. Pencils offset for left hand use.

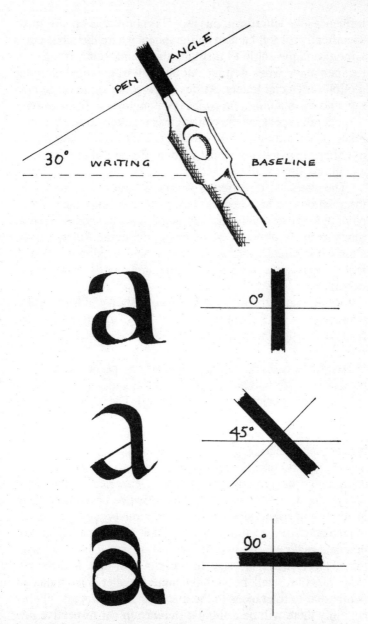

Fig 6. The effect of a change in pen angle demonstrated on the letter 'a'.

influences the letterform; this aspect is noticeable on nibs made specifically for left handed calligraphers where the nib is cut at a more oblique angle to facilitate the maintenance of the correct pen angle when writing. All this will be enlarged on in the section on Uncial letters. At this stage concentrate on achieving, and maintaining, the correct pen angle as defined above.

Generally speaking the pen angle is maintained in a constant relationship throughout an alphabet. This means that you *do not alter the pen angle* whilst writing. Be careful of this as it is a common fault with beginners.

The character of differing scripts is largely determined by the relationship between the basic shape of the letter and its pen angle. Historically the pen angle has changed at various times from the almost vertical angle of Roman Rustics to the almost horizontal angle of the Irish Half Uncial, but it is normally consistent within any alphabet, with only minor variations.

How dramatic the difference can be is shown in **fig 6**, which demonstrates on the letter 'a' the effect of changing the pen angle on vertical/horizontal/diagonal/curved strokes.

Height In calligraphy, the height of any particular script is measured in nib widths (that is to say the width of the nib that is in use for a particular piece of writing). The basic unit is that of the 'x height' of the minuscule (lower case) letters. The term 'x height' refers literally to the height of the letter x. All other measurements derive from, and relate to, this basic unit.

It should be understood that there are no absolute rules in calligraphy, only guidelines based on experience, and upon accepted practice by expert scribes. However, even here there is room for slight differences of opinion because, as in all human activities, accuracy and precision are abstract ideals not practical realities. If you write with your size 1 nib and I with mine, the chances are that the results will appear different. Your nib may well be slightly larger/smaller than mine, in width, due to tolerances in the manufacturing process; almost certainly there will be a slight difference in our respective *pen*

angles, even though we may be *aiming* at the same exact angle; and for quite certain we will write with different pressure on the pen.

All of the above factors will affect the appearance of the finished work.

To quote the German lettering artist Walter Kaech: *'At all times the eye is the final arbiter'*. (Try saying it in a heavy German accent; it will be more memorable that way.) In other words if it looks right, it is right; and if it doesn't, it isn't!

I hope that, as you work your way through this book, you will become more perceptive as to what *looks right*; also that you will try to analyse why something may not look right, and then make *your decision* as to what is needed to correct things.

Weight refers to the *ratio between the maximum stroke thickness and the 'x height'* of the letters. The stroke thickness is determined by the width of the nib and, in calligraphy, the height of a script is given in 'nib widths' drawn at right angles to the baseline. In **fig 7** you can see the effect on a Round Hand 'o' at differing heights using the same width nib. Note the effect on the internal shape of the letter. The effect on the letter 'a' is shown also.

Ruling Up

Ruling lines is not the world's most exciting work so it's as well to 'do it well, and do it once'. In mediaeval manuscripts (MSS) the scribes had to make do with relatively primitive implements but they did invent reliable short cuts to speed up the process. The first device was to use dividers rather than rulers. Dividers (like a compass, but with two points) will give you the most consistent measurement between the lines. The most reliable types are those with a centre wheel/screw adjustment. Not only are they accurate but, when you prick the paper, you are marking up both sides of the paper at once, and it is possible to prick through several sheets simultaneously, and thus ensure consistent measurements over a number of pages.

If you only have a ruler against which to draw your lines

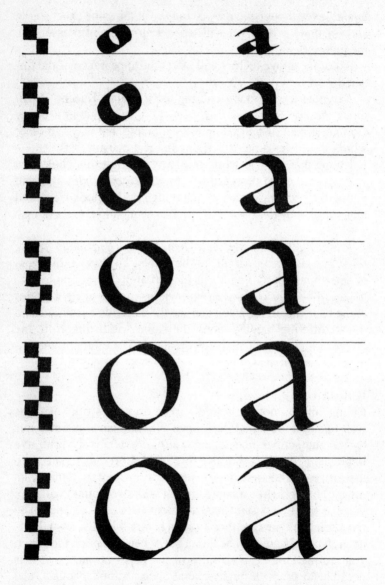

Fig 7. Diagram showing the effect of changing the weight, shape, height on letters 'o' and 'a'. The 'check' pattern on the left shows the height in nib widths.

then you will have to prick measurements down both edges of the sheet but, if you have a T square or a drawing board with a parallel motion trammel on it, then it is only necessary to prick one set of measurements down the centre of the paper. (Using the centre minimises any inaccuracies inherent in the tools.)

Looking at old MSS in museums, etc., is a good learning process. After you have marvelled at the richness of the decoration/illumination, the glitter of the gilding and the supreme skill of the penmanship, take a close look at the ruling up technique. Sometimes there are no marks at all in the normal sense; rather there are grooves and ridges on facing pages where the scribe has used a metal stylus to indent the surface of the parchment (which makes ridges on the reverse side). In another MSS you may see the lines ruled in a colour, often red; here the lines are intended to become very much part of the overall visual effect. With this type of ruling the letters are written between the lines, rather than tight to the lines, see **fig 8**, with the ruled lines just acting as guidelines. What you will notice in all the MSS is that the lines have not been erased; all are observable but faint. If the lines are of the correct quality they do not need to be rubbed out.

When ruling up on paper you should use a sharp, mid-grade pencil (say H or HB); the sharpness is more important than the grade. There are two aspects that are paramount. Firstly, the accuracy: the prick mark must be just visible against the edge of the ruler, T square or trammel; secondly, lightness of touch: the lines should be just visible, no more.

To maintain a constant height to your letters you will need pairs of lines when you start. With time and practice your writing will become rhythmical and regular so that you need only a baseline. Some really talented calligraphers work on occasions without any lines at all, totally relying on their skill, experience and intuition.

writing accurate
ly on the lines is
the normal way

the lines·may·be
part·of·the·design

undulations
may express
movement

Fig 8. Ruling up.

2

MAKING GOOD LETTERS

FOUNDATION (or ROUND) HAND

'In the beginning was the word'. So says the Bible in St John Chapter 1 Verse 1; and the word was written in capital letters. This fact is easily overlooked nowadays because the vast majority of words are now written and printed in what children call 'small letters', printers call 'lower case' and calligraphers call 'minuscules'. However, up until about 600 AD, there were no small letters as we know them; so everything – books, inscriptions, even notes to a lover – was written in capital letters. Incidentally, printers call them 'upper case' and calligraphers call them 'majuscules'.

Our capital letters evolved from several earlier alphabets used by the Greeks and the Cretans before the birth of Christ, and were adapted and refined by the Romans, who developed them into the highly finished letterforms that we now call the 'Roman' alphabet.

Foundation Hand Capitals

The first characteristic that must be learned is that of proportion, which is the term used to describe the width of a letter relative to its height. Whilst introducing the Foundation Hand (this term is interchangeable with Round Hand), I will look at the width first. Most people when asked to write a simple capital letter alphabet will produce letters which are very similar in width, see **fig 9**. When you look closely at these freely written letters (almost a scribble), you will notice that some of the letters are naturally wide – MW – and others are narrow –

PACK·MY·BOX·WITH
FIVE·DOZEN·LI Q
UOR·JUGS·123456

QCDG
AHNTJ
UXYZI
BEFKLP
RSMW

1
2
3
4
5
6
7
8
9
0

Figs. 9 and 10 The V is the middle of the /\\

IJ – but most of the remainder are roughly the same width, as are the numbers.

However, the true Roman alphabet has letters which are clearly different in width. There is a group of wide letters – CDGQ – deriving from the letter O; also MW are wide; then comes a group of medium letters – AHNTUVXYZ – which are all approximately ¾ of a square; next there is a group of narrow letters – BEFKLPRS – which are all approximately ½ a square wide; whilst I and J are a particularly narrow pair for obvious reasons, see **fig 10**.

Notice also that the middle bars in the capital letters like E and H are not drawn exactly midway between the top/bottom lines, but are positioned either a little above the mid line or a little below it. This corrects the optical illusion that makes the letters look unbalanced if they are divided exactly in half.

There are a number of easy aids to commit these fundamental facts to memory:—

1. The medium width letters are symmetrical.
2. The narrow letters are asymmetrical.
3. Letters which have two similar shapes arranged vertically (EHX, etc.) have raised mid points.
4. Letters which have dissimilar shapes (AFY, etc.) have mid points lowered.

The numerals I have illustrated are all approximately the same width. This allows the numbers to be used in vertical columns neatly and clearly, and is a common aspect in the design of numerals in many alphabets. (It is interesting to note that our numerals originate from the Indo/Arabic tradition, and so were never likely to conform to the pattern of letters deriving from Graeco/Roman sources.)

It is essential to be able to draw and write capitals, with the correct proportions, almost automatically. It is helpful to start by making skeleton letters in a soft pencil on graph paper to get a measure of accuracy, see **fig 11**.

The figure shows an 'alphabetic sentence' SPHINX OF BLACK QUARTZ JUDGE MY VOW. Similar sentences are A QUICK BROWN FOX JUMPS OVER THE LAZY DOG, and

SPHINX
OF BLACK
QUARTZ
JUDGE
MYVOW

Fig 11. Capitals in proportion.

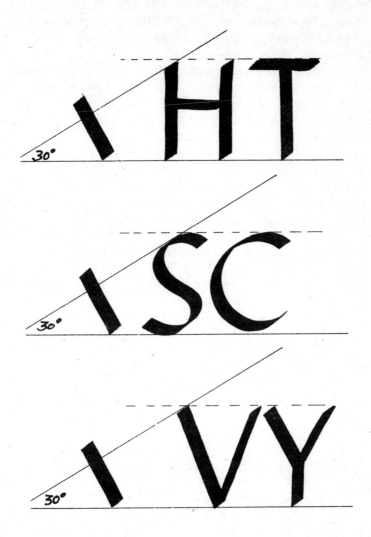

Fig 12.

PACK MY BOX WITH FIVE DOZEN LIQUOR JUGS. Practise these in a soft pencil (say B/2B), on 5mm graph paper, at about 20mm high, until the correct proportions are almost automatic.

Once this aspect is mastered it is time to move on to a piece of calligraphy using the broad edged pen. First, try using a 5mm felt tip calligraphy pen to carry out the above initial exercise. Here, one becomes aware of the effect of the broad edged pen on the capital letters.

If you hold your pen to produce a 30 degree *pen angle* you will notice that the thinnest mark/line is made at that angle, whereas the thickest mark is one made at right angles to the thin line. When simple vertical and horizontal lines are made at this pen angle, thick and thin strokes are created with a ratio of stroke thickness of 2 to 1. Thus the vertical strokes are twice as thick as the horizontal ones, see **fig 12**. When curved strokes are made then there is a gradual change from thin to thick and back again. The diagonal strokes will also have a different thickness dependent on their angle.

All capital letters are made up from six basic strokes: vertical/horizontal; left curve/right curve; left diagonal/right diagonal. It is good practice at first to create a pattern from these six strokes so as to gain freedom and consistency, see **fig 13**. Having tried this with the felt pen, then move on to the dip pen. Maintain the 30 degree pen angle for all the strokes/letters at all times. Before writing out words it is as well to write the letters in groups which use the same strokes. These groups, see **fig 14**, are:

- vertical/horizontal ILTFEH
- left/right diagonals VWXM AKNYZ
- left/right curves OCDG BPRSU

Appraise yourself, see **fig 15** during this exercise, how all the strokes are made by pulling the pen across the paper; the pen either moves from top to bottom, or from left to right.

Now try writing out the alphabetic sentences above, using the broad edged pen on plain paper which you have ruled up to a height of 5 nib widths, with 3 nib widths between the lines,

Fig. 13.

ILTFEH

VWXM

AKNYZ

OCDG

BRPSU

Fig 14.

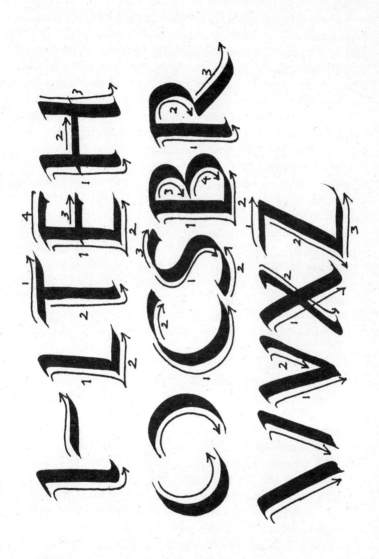

Fig 15.

as shown on **fig 16** opposite.

Writing on graph paper – should you prefer to – helps accuracy, especially in keeping the vertical strokes truly upright. The strokes must be made carefully; your aim is to develop control and consistency. It is probably true to describe the technique as being similar to drawing as much as to writing. Take care to maintain the 30 degree pen angle for all these capitals.

I have suggested that you write with a large (5mm), square cut, calligraphy felt pen to do the initial exercises. Felt pens always write first time with a good ink flow so you can concentrate completely on the fundamentals of letter shape/width, stroke direction and sequence. When you have gained a measure of consistency and confidence you should move on to using the dip pen at all times.

It is difficult to anticipate how successful your first attempts at using a dip pen will be. There are three main variables: pen/ink/paper. If you buy the types suggested in Chapter One, the ink and paper should present few problems. The pen, more specifically the nib, is another matter. If you are lucky all will go well; unhappily, the manufacture of steel nibs seems not to be an exact science and the quality seems to be somewhat erratic.

The following tips will obviate most problems:

1. Check that the slit/split of the nib is not open. When you hold the nib up to the light there should be no apparent gap. (The ink is carried to the tip of the nib by capillary action – this will not work if there is an observable gap.)

2. Hold a new nib in the flame of a match or candle for about 3–4 seconds. This will burn off the coating that is put on the nib to prevent rust before you buy it.

3. If you are using Mitchell Round Hand nibs, when you fit the reservoir make sure that it does not cause the split to open (a common fault). Also ensure that the tip of the reservoir is actually touching the under-side of the nib, and is positioned about 2mm from the end of the nib; the flow of the ink can, if necessary, be finely adjusted by slightly altering this distance.

PACK·MY·BOX
WITH·FIVE·DOZEN
LIQUOR·JUGS

Fig 16.

4. The ink should be in the space formed by the nib and reservoir: some ink bottles come with a dropper in the lid to feed the ink into this space; or it can be done with a small brush; if you dip the pen into the ink (that's how it got its name), be sure to take off the surplus by touching the nib on some rag/paper tissue before starting to write

5. Be aware that, like shoes, nibs need to be 'worn in' before they are at their best; also that you are are pursuing a craft, the success of which is related to the amount of time, etc., that you are prepared to spend on it.

When all aspects are working correctly the nib should make a thin mark when it is slid gently sideways along its edge. This tiny, sideways movement spreads the ink across the whole width of the nib and thus enables a broad stroke to be written. The ever-so-slight sideways movement is used to create the point (known as a serif) at the beginning of strokes; a similar movement at the end of the stroke allows a neat finish to be made.

Foundation Hand Minuscules

In the first decade of the 20th century, Edward Johnston, the founding father of current British calligraphy, researched and analysed many different historic manuscripts at the British Museum and used one of them, 'Harley 2904' (sometimes known as the Winchester Bible), as the model for his 'Foundational Hand' alphabet.

He thought that this script, written in a Winchester scriptorium during the 10th century, made an ideal place from which to start when creating a basic script for would-be scribes to emulate at the beginning of their calligraphic studies.

I always find that human analogies are helpful when trying to gain an initial understanding of the essential concepts. To this end I see the letters 'o' and 'i' as the Mother and Father of the alphabetic family. The letter 'o' in this script may be seen as essentially circular, where the broad edged pen (or, in the first examples, the twin pencil tool) forms two overlapping circles which are made by the corners of the pen/tool, see

fig 17. The 'i' shows most clearly the attitude of the alphabet (whether it is upright/sloped, etc.), and also the nature of its serifs/stroke endings.

The height of the letter 'o' is 4 nib widths. (Remember the width of the nib in use is the standard unit used to gauge the height of any script. See *Height and Weight* and **fig 7**, pages 20–22.)

These three factors determine the basic character of the 'Foundation Hand':

1. The basic shape is a circle (from which the alternative name 'Round Hand' derives).
2. The Height/Weight is determined by the number of nib widths.
3. The inner shape is caused by the 30 degree pen angle.

The overlapping circles create 'crossover' points which enable a consistent construction method to be adopted. The vertical strokes are normally drawn with their inner edge passing through these points as in the minuscule letters bpdq in **fig 17**. In this way all these letters share a family likeness.

In a similar manner the letters hmnu, and the main stroke of the letter 'a' share similar basic characteristics.

The letters ces can be seen as being made up from parts of the 'o', thus extending the family likeness aspect. Indeed, all the letters in this script, except those formed by diagonal strokes (vwxyz and part of 'k'), are made up from verticals and parts of the circular letter 'o', see **fig 18**. Even the curves at the top of the 'f' and the bottom of the 'j' can be seen as the top and bottom of an 's'; and the 'r' can be seen as part of the 'n'. Thus most of the letters in the alphabet are formed from combinations of a few basic strokes – a left or counter clockwise curve, a right or clockwise curve; a long or short vertical; and left and/or right diagonals. Simple isn't it?

There is a slight change of pen angle, to 45 degrees, needed for both left and right diagonal strokes that make up the letters vwxyz. This is to make the points at the bottom of the letters easier to form, and also to keep the stroke thickness ratio similar to that of the vertical/horizontal, see **fig 18**.

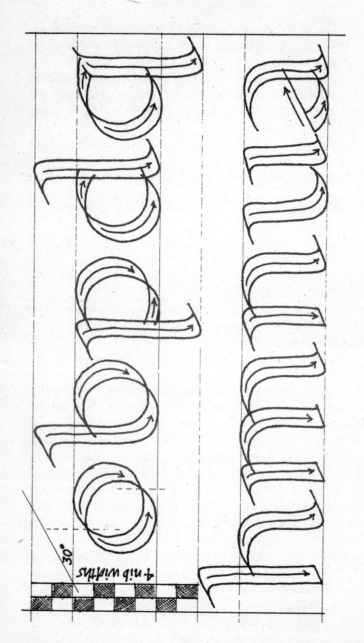

4 nib widths

30°

Fig 17.

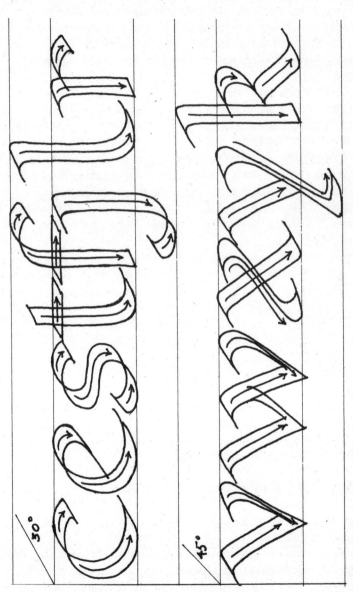

Fig 18. Change of pen angle for diagonals.

When using a broad edged dip pen the strokes must be made in a top to bottom, or left to right, direction as first shown in **fig 12**. By following this method you will be pulling the pen across the paper, not pushing it. The pulling motion allows the pen to move smoothly across the paper rather than digging into it.

To start practising the minuscules in this Foundation Hand script it helps enormously to write out the alphabet with the letter 'n' in between each letter – anbncndnen, etc . . . , see **fig 19**, in order to establish the general *visual* rhythm of the script.

Writing, even careful and deliberate writing, has to be a rhythmic activity if the outcome is to look good; so the development of this rhythm is fundamental to good calligraphy.

Also vitally important, at the beginning, is to familiarise yourself with the 'family' groups that make up the alphabet. These are – iltfj; hmnurak; ceosg; bpdq; vwxyz; so practise writing out this sequence as well – inlntnfnjn, hnmnunrnankn, cnenonsngn, bnpndnqn, vnwnxnynz, see **fig 20**. This will reinforce the family groupings and develop the rhythm at the same time. Think of these exercises as being like practising the scales on a piano; the two most important aspects are that you achieve correctly formed letters, and that they are written rhythmically.

A finished exemplar (**fig 21**) for you to carry out is a little piece of nonsense verse –

> Higamus, hogamus, girls are monogamous;
> Hogamus, higamus, men are polygamous!

Space out your lines with the height of two 'o's between them to ensure good line spacing.

Compressed Round Hand Minuscules

In all aspects of human life, economy has a significant influence. The need for such economy may be of time, money, energy or materials.

Throughout history the cost and availability of materials have influenced the size and shape of the scripts used in books, and there has been a tendency to make letters narrower

Fig 19

Fig 20.

Higamus hogamus

girls are monogamous

Hogamus higamus

men are polygamous

Fig 21

(condensed) in order to get more letters/words on each line. This condensing or compressing of the letters also allows for tighter line spacing, and consequently, smaller margins. This tendency towards compression was most evident in the Gothic period (1100–1400 AD), when calligraphy was the only means of making books.

The Compressed Round Hand may thus be seen as a simple, modern 'gothic' script; with its emphasis on repeated vertical strokes with minimal space between them.

A compressed letter is normally regarded as simply one whose width is less than its height. However, especially on minuscules, the degree of compression allows for some measure of personal interpretation. For example, in **fig 22**, the height of the 'o', shown on the left for comparison, is increased to five nib widths, whilst the pen angle remains at 30 degrees.

The shape of the arch at the top/bottom of the compressed 'o' is a circle; but, unlike the Foundation Round Hand this 'o' is formed by two smaller, and hence narrower circles (not one full size circle), see **fig 22**. As you can see, the construction of the letters hmn also works in the same way to that of the Foundational inasmuch as the vertical stems of the letter also pass through the intersections of the overlapping circles. **In this way the letter is made narrower (relative to its height) but it retains the essential 'round' characteristic.**

Likewise in concert, when the Foundation script is compressed, are the family groups of letters which are made up of similar parts.To remind you, these groups are: ceos – bpdq – iltfj – hmnurk – vwxyz. Notice that both 'a' and 'g' can be made in two alternative versions, see **fig 23**.

You will succeed best if you practise writing the family groups first to reinforce these common parts; then write out the alphabet with an 'n' between each letter to establish the visual rhythm of the script, see **fig 24**; and then write out one of the 'alphabetic sentences' such as 'A quick brown fox', see page 27 and **fig 25**.

The finished piece that I have included is from the Bible text of Genesis Chapter 1. I have presented this in the form of a

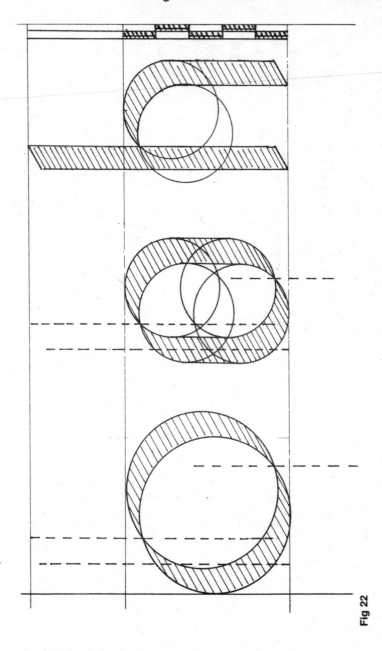

Fig 22

ceosg

bpdqag

iltfj ag

hmnurk

vwxyz

1234567890

Fig 23.

ambnendnenfngn
hminjnknlnmnon
pnqnrnsntnunvn
wnxnynz1234567890

Fig 24.

Sphinx
of·black·quartz
judge·my·vow

Fig 25.

double page opening of a small but simple book as the compressed scripts are essentially book hands, see **fig 26**. They can also be useful for rolls of honour and similar manuscripts, where the length of some of the names can cause problems for the scribe.

Initially, almost all students expect all aspects of calligraphy to be perfectly uniform; it is what they are instinctively aiming for most of the time, especially with the letterforms.

I have included some alternative variations of some letters in the illustrations to show that there is not always a fixed version, but rather a sense of uniformity – brought about by certain factors such as the pen angle, weight, shape and method of construction. Also some combinations of letters work better that others. A study of old manuscripts will reveal the use of abbreviations, ligatures (links), and overlaps. The medieval scribes did not have 500 years of typography to indoctrinate them to expect mechanical perfection.

In the illustration of the book opening, **fig 26**, which was written quite freely on just a baseline (not between pairs of lines), you will find inconsistencies (and mistakes). Calligraphy, by definition, is a human activity and, as such, will exhibit the variations that are inherent in anything handmade. The greater the level of skill, the smaller the range of such variations. Donald Jackson, who is widely regarded as the western world's greatest living scribe, has remarked: *'Calligraphy is not manual typography'*. Only printing will produce mechanically perfect – but rather dead lettering.

Keep practising and consistency, and more importantly rhythm, will come in good time.

Compressed Round Hand Capitals

Historically it is not unusual for capital letters used with minuscule text to be of a noticeably different form; and often this is used to create a definite decorative effect. However in the 20th century it became more usual to develop a matching set of capitals, which exhibit the same characteristics as the minuscules, to accompany and complement them. Therefore,

IN the beginning God crea
ted the Heaven and the
earth. And the earth was with
out form and void: and dark-
ness was upon the face of the
deep. And the Spirit of God
moved upon the face of the
waters. And God said, Let there
be light: and there was light.
And God saw the light, that
it was good: and God divided
the light from the darkness.

Fig 26.

And God called the light Day
and the darkness he called
Night. And the evening and
the morning were the first
day. And God said, Let there
be a firmament in the midst
of the waters, and let it divide
the waters from the waters.
And God called the firma-
ment Heaven, and the even-
ing and the morning were
the second day.

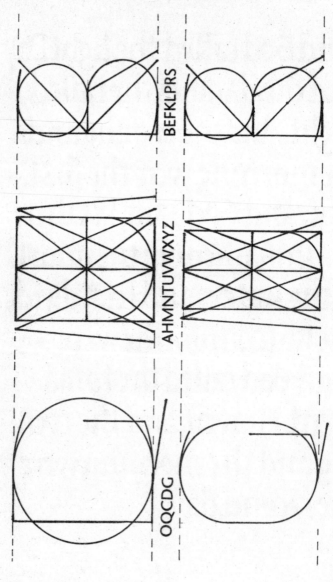

BEFKLPRS

AHMNTUVWXYZ

OQCDG

Figs 27 and 28

the capitals used with the Compressed Round Hand minuscules need to be similarly compressed, have the same pen angle and weight, and be based on a circular form in the curved parts of the letters.

The alphabet of Round Hand capitals has a system of letterforms wherein there are three observable groups of letters, viz. Wide/Medium/Narrow. These groups are still evident in the compressed version, but the differences are less dramatic.

The easiest method of learning this grouping is to draw them on a common framework and then to condense them in a similar manner, see **fig 27**. The illustration shows the underlying geometry of capital letters that divides the alphabet into Wide OQCDG, Medium AHNUTXYZ, Narrow BEFLKPRS groups. Underneath in **fig 28** can be seen how the method translates into a coherent set of compressed letters.

Notice in **figs 27 and 28** that the diagrams simply demonstrate how the geometry that underlies the normal letters in the top row is transposed onto a compressed module beneath. In this way the O is still wider than the CDG in both versions, as is the M compared to the other letters on that module (the W is literally a double V); and the 'narrow' group are hardly altered at all (including I and J).

When written the final appearance of these compressed capital letters can be seen in **fig 29**.

Capital Initial Letters and Mixed Work

The relationship between the height of capitals and minuscules (in almost all alphabets) is often a source of mistakes in beginners' work. Unfortunately, when we are taught to write at school, it is the norm for children to be told to make the capitals double the height of the 'small' letters; this leads to a disproportionate relationship between them.

The generally accepted relationship is seen in the illustration, **fig 30**. Notice that the capitals are slightly shorter than the ascenders of the minuscules.

The length of ascenders/descenders, relative to the 'x height', is open to variation and personal interpretation. (NB

Fig 29.

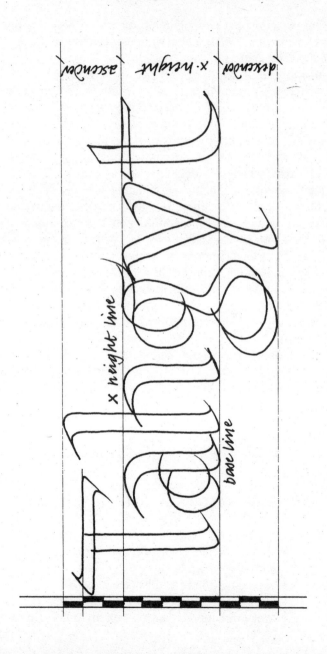

Fig 30.

the term 'x height' is a typographic means of defining the height of a minuscule letter that is without ascenders or descenders; e.g. aceimno etc.)

Incidentally, it is worth noting that the descenders of all relevant letters are normally the same length as ascenders, in most scripts. Both can, of course, be used to great effect to embellish the head/foot of decorative pieces of work.

Ratios of 3:2, 5:3, 8:5 are all part of the Fibonacci number series and, as such, are all approximations of the 'Golden Ratio' (1:1.618) which is widely regarded as a perfect proportion in art and design. (This is a fascinating subject which has wide cultural significance; there is a good introduction to it in the Encyclopaedia Britannica should you wish to find out more.) I therefore advise students to start with them and only make changes to them in order to achieve a particular effect. You should understand, however, that all of these sizes, proportions etc., are suggested guidelines, not absolute rules and regulations. They are simply relationships, established by usage, to give you a starting point of sound exemplars from which to depart.

It is worth drawing to your attention here, in **fig 30**, that the minuscule 't' is not as tall as fhlk, and that the crossbar runs underneath the 'x height' line as does the cross bar of the letter 'f'.

Write out the words in **fig 31** so as to develop an automatic sense of the relative heights of capitals and minuscules, especially in relationship to the ascenders, descenders and the letter 't'.

A CHECKLIST FOR ROUND HAND AND COMPRESSED ROUND HAND

Minuscules • 30° pen angle (steeper on diagonal strokes)
- circular arches at the top and bottom of letters with curved strokes
- 'x height' 4/5 nib widths (see page 20)
- ascenders/descenders 3 nib widths larger
- stroke direction either top-bottom or, left-right

Partly·Athens·Kindergarten

Gathered·Scathing·Gently

Yogurt·Bathing·Artlessly

Endlessly·Gentiles·Antlers

Fig 31.

Capitals
- • family groups of similar shapes/strokes
- • pen angle as minuscules
- • 2:1 stroke weight ratio vertical:horizontal
- • circular shape to curved letters/strokes
- • height slightly less than ascenders
- • three basic letter widths – wide/medium/narrow.

Three Essentials

To conclude these two basic alphabets it is opportune to consider another famous Edward Johnston dictum:

'Three essentials of fine writing are Sharpness, Unity and Freedom.'

Sharpness is largely technical in that it demands that the three main elements – pen, paper and ink – are all as good as one can get them.

The pen should give clean edges to the thick strokes and also give fine hairlines when slid along its edge at the start and finish of the strokes, see **fig 32**.

The ink needs to be the right consistency – thick enough to be opaque but not to clog the pen, thin enough to flow fluently through the pen but not to spread or blob on the paper.

The paper needs to be smooth enough for the pen to move freely across the surface but not to slip; absorbent enough to hold the ink but not to allow it to spread (like on blotting paper).

It is possible to prepare paper (and some other surfaces) if necessary, by abrading the surface with very fine silicone carbide paper (grade 600 – 1200). This will remove some of the excess fibres on coarser papers and also give a little tooth to papers which are too smooth. Dusting the surface with powdered Sandarac resin will prevent the ink from spreading in some over-absorbent papers.

Grease on the surface can be removed by abrading with a soft rubber/eraser and dusting with a 'pounce' which is a mixture of fine pumice powder and gilders' whiting. These craft processes are necessary when you are trying to achieve the

Fig 32.

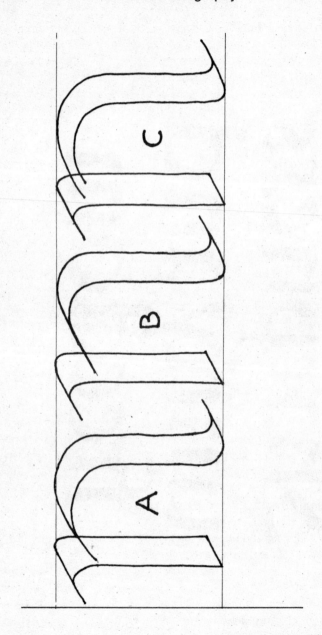

Fig 33

finest possible results for a special piece of work. Their effects, and consequently the need for any or all of them, can only be gauged by trial and error. Remember always, calligraphy is a human activity, not an exact science.

The visual aspect of sharpness can be enhanced by ensuring that the fundamental quality of the broad edged pen is maximised by producing the strongest possible contrast in the combinations of stem and arch construction. In **fig 33**:

A shows the best possible result, where the arch starts with a sharp point as it leaves the stem
B: starting the arch too low tends to create the wrong shape of arch and produces an initially thin line which lessens the contrast and creates a weak arch
C: starting the arch too high causes an overlap which gives a strong join but also a blunt, clumsy effect where the thick/thin contrast is lost.

Unity is gained by having a single shape/construction underlying all the letters; it is produced by
• constant *weight* deriving from correct pen angle
• constant use of the circular arch shape
• constant method of construction
• constant amounts of white space within and around letters.
This last aspect will be explained in greater detail later; suffice to say now that unity and rhythm go hand in hand, and both are gained by making the main down strokes at regular intervals; that is to say evenly spaced.

Freedom Edward Johnston also remarked: *'within the discipline of our craft we cannot have too much freedom'*.

Disciplined freedom can only come from regular practice, mastery of the essentials, self confidence and the realisation that calligraphy is in some respects like a theatrical performance: you learn your lines; you rehearse; have a dress rehearsal, even; but ultimately you have to give the performance (which may well mean in front of an audience when

demonstrating).

In calligraphy all your skills must pull together from start to finish, complete with mistakes.

It is through this concept of individual artistic freedom, within a historically recognised and evolutionary framework, that personal artistry can flourish. When writing, that freedom is the ultimate goal; it is something which normally only comes with several years' experience; but you have to know what the target is before you can aim at it.

ITALIC SCRIPT

This alphabet originated in that tumultuous period in human history known as the Renaissance. Thus it was that, in the 15th century, there was a great revival of interest in the 'Classical' period. The latter ran from approximately 500 BC–500 AD and was a time when many aspects of Western civilisation and culture originated. The Roman capital letterforms became formalised then, and so they became the norm again during the Renaissance. However, there were no formal lower case/minuscule letters in the Classical period. When the 15th century scribes looked for a script to use with the Roman capitals, they focused on the Carolingian minuscule which originated in the 8th century, during the reign of Charlemagne.

These round, fluent letterforms were adopted, and adapted, by the Renaissance scribes and became known as 'Humanist' minuscules. In appearance they were very similar to the foundational, Round Hand letters that you have just learned.

At the same time, around 1450 AD, the invention of printing from movable metal type was coming into everyday use. This put pressure on the scribes; they now had to compete with the printing press as a means of producing both books and other formal documents.

Try a little experiment. Close your eyes and write *hilo* about five times quite quickly, see **fig 34**.

If you do it quickly, freely and unselfconsciously – with your eyes shut so that you do not see the result until you have finished, you will probably find your letters are similar to mine

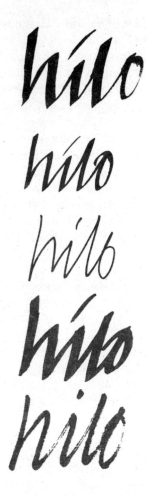

Fig 34.

(which were written with a variety of pens, markers, etc.) inasmuch as that –

- the letters will lean to the right (assuming you are right handed)
- the 'o's will be compressed into an oval shape
- the arches in the 'h's will branch upwards from the bottom of the stem

- probably there will be some ligatures (joins) linking the letters together.

What this demonstrates (even if you do feel a bit silly writing with your eyes shut) is that the main characteristics of the Italic script – forward slant/compressed ovals; branching arches/ligatures – are the result of writing quickly. Which is probably just what the Renaissance scribes did when they were put under pressure by their employers in the Chanceries (offices) of the Vatican in Rome. Indeed, the Italic script was originally named *'cancelleresca corsiva'* (*'the running office'*) script. A closer look at these factors will explain why.

When walking, your body is upright; when you start to run, you lean forward a little. This maintains your balance against the forward momentum. The faster you run, the greater the forward lean you need.

Making an accurate circular O is a slow process. A circle is an absolute shape and it has to be made carefully. Speed it up and rhythm will take over. Also, an oval shape will probably be made in one movement, rather than two halves in opposite directions.

When writing a Round Hand 'h', you lift the pen off the paper at the bottom of the main stem, move it up to where the arch starts, put the pen back onto the paper and make a careful circular arch finishing on the baseline. At speed there isn't time to lift the pen. You simply leave it on the paper and 'bounce' it upwards off the baseline as you start to make the arch. In this way the branching arch takes shape.

Equally, there isn't time to keep lifting the pen between letters. Ligatures, which are the joins between letters, are another result of writing quickly; indeed, when people do a lot of writing, they sometimes even join words together.

Formal Italic Minuscules

Although the main characteristics of Italic script are the result of writing more quickly, it is normal for calligraphers to accept most of these aspects but to make the script more formal by omitting the ligatures between the letters and, sometimes, by

making certain parts of the letters more complex and finished. This particularly applies to the ends of the strokes. Obviously, this rather negates the speed factor, but it makes for a more attractive and decorative letter.

Height/Weight An 'x height' of 5 nib widths gives a lighter, more elegant character to this script. The weight ratio is approximately 14% (one in seven) of the height, compared to the approximately 20% (one in five) of the Round Hand script which is a heavier, more solid script. The height/weight relationship is affected both by the pen angle and the 'x height'; altering either will change the density of the overall appearance of a piece of writing.

Pen angle A 40 degree angle (which is a little flatter than the 45 degrees which is normally given for Italic) ensures that the stems and horizontal parts are approximately equal in weight. This avoids the visual weakness in the stems which is apparent in many Italic scripts written with a 45 degree angle.

Slant About 5 degrees from the vertical, for the upright stems, is enough to make the forward slant quite clear and, this in turn accentuates the restraint that is important in formal scripts.

Compression In **fig 35** I have used the 'Golden Ratio' mentioned earlier on page 56 (here 8:5) to establish the width of the parallelogram that contains most of the letters. Because the oval, unlike the circle, is not an absolute shape, it is a variable that can be exploited in order to achieve differing degrees of compression. It is important, however, to maintain a constant amount of compression in any one piece of work.

Branching arches – In **fig 35** the construction shows that the Italic stems do not pass through the intersections of the overlapping ovals (as they do in the Round Hand script). In Italic the stems coincide with the outer edges of the ovals. This results in most of the letters being the same width as the O. In

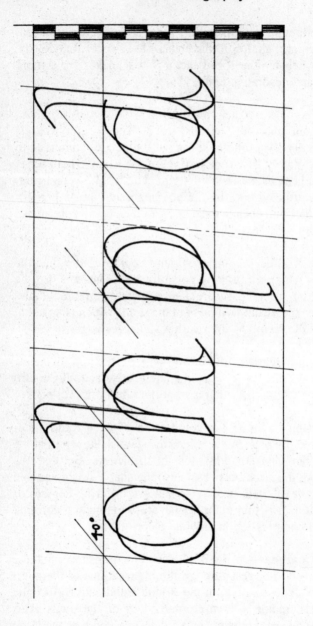

70°

Fig 35.

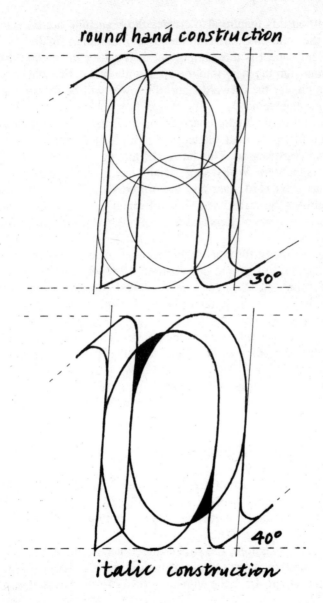

Fig 36.

addition this feature also creates the branching arches shown by the solid black areas in the lower diagram in **fig 36**.

This aspect is most important as it causes the smooth transition from the stem into the arch, without a noticeable corner. The greater the forward slant, the lower will be the arch as it leaves the stem.

Contrast this Italic construction with that in the upper diagram of **fig 36** of a slanted letter 'n' created with the Round Hand construction. This has a definite corner where the arch meets the stem. Whilst superficially like the Italic, inasmuch as it has a forward slant and is compressed, it would be more accurately described as a sloped Roman 'n'. This form is well known to typographers and is often referred to, erroneously, as Italic.

Incidentally, throughout this book my construction diagrams are carefully drawn to demonstrate the theory that lies behind each alphabet. However, when you or I come to write the letters within an individual piece of work, then our human fallibility takes over! The letters rarely match up to this 'perfect' ideal; but we need this ideal form to aim at, and to inform our understanding of how, and why, the letters are shaped as they are.

The family groups in Italic are a little different from the Round Hand groups as you can see in **fig 37**. In Italic the 'a' and 'g' have the same basic shape as the 'd' and 'q', viz. adgqbp.

Firstly, practise the family groups ceos – ifj – adgq – ltu – bkprhmn – vwxyz.

As before, you will need to steepen your pen angle a little for the diagonal strokes. Look at **fig 38**, then practise 'the rhythm method' sequence – anbncndnenfngn etc. – as explained on page 40.

Again, as before, the stroke directions are mainly pulled – top to bottom or left to right. However, the arches of the letters bdghkmnpqru are made with an upstroke from the baseline, see **fig 37**.

Because Italic derived from quickly and freely written

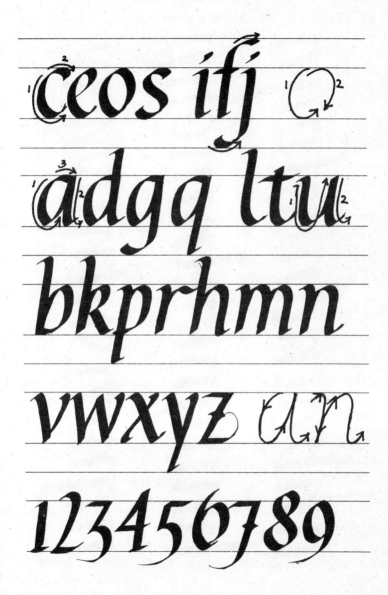

ceos ifj

adgq ltu

bkprhmn

vwxyz

123456789

Fig 37.

Fig 38.

letters, there is always an inclination to write it with as few pen lifts as possible. Often just the size of the letters or the surface quality of the paper will determine whether you can make a letter in one continuous stroke or whether you need to lift the pen, move it to the top again, and then start to pull the stroke.

Reference to **fig 37** will show how letters may be made in a number of separate strokes as with the c a and u in the diagram; whereas the skeleton letters a and n show how some letters may alternatively be made in a continuous movement without lifting the pen.

Practical experience will soon enable you to make these decisions for yourself. Your aim should be to make all the letters in Italic script freely and rhythmically.

When making any branching arch upstroke there should be as little pressure on the pen as possible, to stop it digging in to the paper. The same applies to the short right to left push strokes which are an alternative method of starting the letters adgq.

Serifs are the terminals of the strokes on letters. As one of my students once said 'Ah! You mean the pointy bits'. They don't have to be pointed but they often are. **Fig 39** shows a range of methods of starting and finishing strokes, some formal and some less so. Generally speaking, the more complex they are, then the more formal they are and the slower they are to carry out. Serifs made up from more than one part are known as 'built up serifs'.

Versatility has made Italic the most popular script with contemporary scribes because, as I have been explaining, it is so versatile. A circular O is an absolute shape; not so an oval *O*. Equally, a letter is either vertical or it isn't; the degree of slant may be varied. Also there is a variety of ways of finishing the strokes. By manipulating these three characteristics – shape, slant and serifs – the scribe can fine tune his letters to suit the nature of the task in hand: formal or frivolous; light or heavy; fat or thin; traditional or avant garde; there's a version of Italic

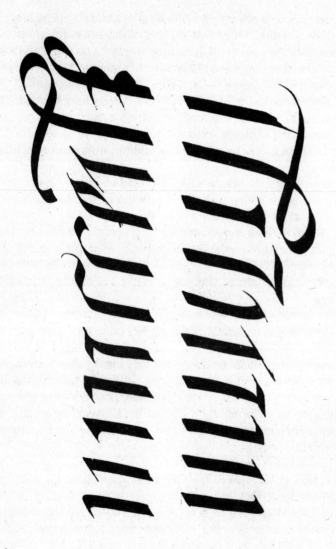

Fig 39.

that will match the mood and meaning of the words.

Fig 40 shows how changing your serifs can alter the appearance of your work quite considerably. Do therefore consider your purpose, always, because the simpler a letter is, then the easier it is to read it; conversely, the more elaborate or decorative the letters, then the greater will be the degree of illegibility overall.

Practising this alphabet in the alphabetic sentences (A quick brown fox . . etc., see page 27) will develop your ability to 'bounce' your pen upwards off the baseline. In **fig 41**, you can also see a little meaningful play on the word 'jumps'.

I have chosen a piece of poetry for you to copy, see **fig 42**. It never ceases to surprise me what a talented poet this chap 'Anonymous' really is; and how wise!

From its inception, Italic has always been seen as especially suitable for poetry. Many of the original Renaissance manuscripts to be seen in museums such as the British Library (which has a wonderful collection of historic manuscripts from all periods on display) show Italic used in this way. The Odes of Horace and Virgil's 'Georgics' were especially popular, and were therefore a good money spinner with the wealthy merchants of Florence and Venice who, as fine books were becoming the status symbols of their day, were building up grand libraries with which to impress their friends and rivals.

There is also an excellent collection of modern (20th century) manuscripts at the Victoria & Albert Museum. These are not normally on permanent display, but are accessible to serious students of calligraphy.

Italic Capitals

In the Renaissance period, when the Italic script came into being, the capitals used were simply straightforward, upright, Roman capitals. They were neither slanted nor condensed. Relatively few capitals normally being needed in any document, it did not matter overmuch that they were slower to make. The convention of only using capitals for the initial letter of sentences, paragraphs, etc., and of using them for titles

Informality

Informality

Informality

Informality

Informality

Fig 40.

The·quick
brown·fox
jumps
over·the
lazy·dog

Fig 41.

Pure Water

Pure water is the best of drinks,
 that man to man can bring.

But who am I that I should have,
 the best of everything.

Let Princes revel at their pumps,
 & Peers with ponds make free.

For Whisky, Wine, or even Beer,
 is good enough for me.

 Anonymous

Fig 42.

and the initial letter of proper names, had already been established in the Latin world. In the Germanic countries, by way of contrast, all the nouns were capitalised.

As mentioned earlier, the convention nowadays is for each alphabet to have matching capitals to go with its minuscules. Thus Italic minuscules have need of capitals which share similar factors, for example, forward slant, compression and, as explained on page 49, letters of a similar width, see **fig 43**.

When designing an alphabet where all the letters are expected to have a similar width, it should be understood that the aim is to make them *look the same width*, not for them actually to be the same width. It is important to recognise this; otherwise you finish up with the ugly letters, which are all exactly the same width, that you see on car number plates.

In simple terms this means keeping the medium letters – AHNTUVXYZ – about the same width; condensing the wider letters – WMCDGOQ; and widening the narrow letters – BEFLKPRS; whilst the letters I and J tend to stay the same. **Figs 43** and **44** show how this is effected with skeleton letters, and **fig 45** shows the letters when written with the pen. The height of Italic capitals is a little less than that reached by the ascenders when accompanying minuscules.

Again, practise your Italic capitals by writing out alphabetic sentences, concentrating on keeping a constant slope, and an apparently constant width, see **fig 46**.

Cursive (or Informal) Italic

The word cursive stems from the same source as words like current and course, and refers to flowing and running. The essential difference between Formal and Cursive Italic scripts is that, in the latter, there are joins (ligatures) linking together most, but not all, letters within a word.

When Italic came into being, in the 15th century, it quickly spread (like printing) across most of Europe. The scribes, who had been professional writers of books and documents, were made redundant by the printing presses. They soon found a new role, however, as teachers of writing to the newly literate

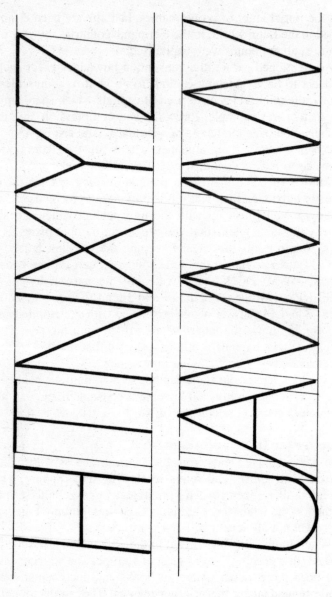

Fig 43.

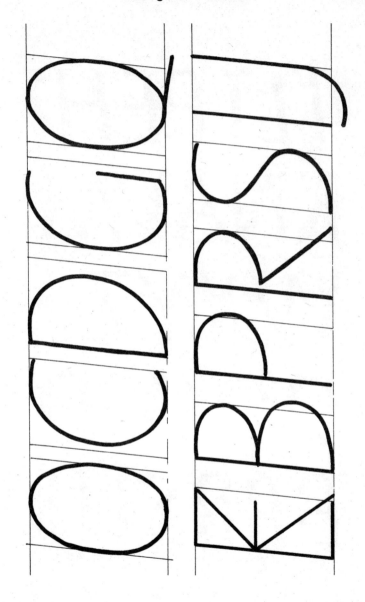

Fig 44.

ILTFEH

KNAVM

WXYZ

OQCGD

BPRSUJ

Fig 45.

SPHINX
OF·BLACK
QUARTZ
JUDGE
MY·VOW

Fig 46.

people who were reading the books made more accessible by
the same printers. Perhaps this was an instance of poetic
justice?

In the 16th century, these 'writing masters', as they became
known, published their copybooks. In Italy, Arrighi, Taglienti,
Palatino and Ampheario were the star names; in Spain,
Francisco Lucas and Juan d'Yciar were spreading the word; in
the Low Countries, Gerard Mercator was teaching the Italic
script, as well as using it to decorate the maps which were his
main claim to fame. In England, at the two main centres of
learning, Oxford and Cambridge, Roger Ascham and
Bartholomew Doddington were spreading the Italic gospel,
which William Shakespeare was to describe in Twelfth Night
as *'that Sweete Roman hand'*.

All educated people were taught the Italic hand, including
Queen Elizabeth I, whose finely flourished signature graced a
plethora of official documents, as well as more personal notes
to certain gentlemen of the court.

Handwriting

In the 1950's there was a revival of interest in Italic script as an
everyday handwriting style. This revival was a reaction against
the 'Copperplate script' (see page 134) which was seen as an
unnatural form of writing, responsible for ailments like 'writer's
cramp'. Italic however, as your eyes-closed experiment was
designed to demonstrate, is based on natural, ergonomic
shapes, movements and ligatures which lend themselves to a
quick, freely written form of legible 'joined-up' handwriting.

The main characteristics of Italic script – the forward slant,
the compressed oval shapes, the branching arches and, in its
cursive form, the joins or ligatures – only need a little care, con-
trol and commitment to turn it into attractive personal
handwriting.

Cursive Minuscules

In its earliest versions Italic was written with a quill pen. This
quickly lost its sharp edge with prolonged use (. . . and writing

this book is quite a prolonged process!). This bluntness of the quill pen nib's edge soon allowed the pen to move upwards when forming the arches, and also to move from right to left, an advantage which meant that it could make many letters with one continuous movement, without pen lifts. This feature of the quill pen was an important factor in the development of the freely running, Cursive Italic script.

Today, using a plastic tip pen or a fountain pen with a smooth nib gives your handwriting the same freedom, unlike the sharp edged metal nibs needed for the best calligraphy.

You will discover therefore, that your choice of pen type will determine how you make some of the letters; as will the size of the pen. There are strokes which are easy with a narrow nib, but which are almost impossible with a broad size of the same type. An instance of this is the short, pushed stroke (right to left) which may be made at the start of the letters adgq and which may finish the letters bp, see page 71 and **fig 47**.

This use of the pushed stroke is very personal; some scribes use it continuously in almost every script, others never use it. It has to do with your temperament (if impetuous or reflective) and also with skill; we tend to do things that come easily, otherwise not. This personal aspect is what makes calligraphy so fascinating as a craft.

There are some letters, such as epqvw, which can be made in either one or two strokes, see **fig 47**, some which have to made with two, such as ftx; just as there are some letters which do not easily ligature to others, such as bpqx.

To return to handwriting for a few moments, this is, and should be, very much a personal thing. Each individual will find that certain combinations of letters will join very easily, whilst others will seem awkward. This is of no matter; the tiny pauses that occur as you lift the pen are helpful in giving a respite from the continuous motion of the ligatured letters, as are the pauses when you stop to dot the 'i's and cross the 't's. Similarly, the spaces between the words perform the same function. In short, the best thing to remember is to 'do what comes naturally'; after all, that's how it all started. Generally

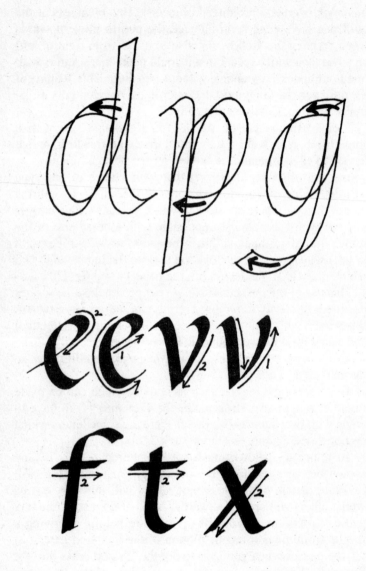

Fig 47.

speaking, loops on ascenders and descenders of hfkjyg are more suited to other styles, such as Copperplate, and do not aid legibility.

Flow and rhythm are the keys to enjoyable and attractive handwriting as in all calligraphy. Concentrate on making consistent shapes within the letters adgqbp, and on keeping regular the occurrence of the down strokes in the letters ilthmnu. Your consistent and regular script will inevitably be leavened by a few awkward letters, such as rcxz, which break the flow and rhythm and make spacing uneven. However, keeping a close watch on the overall pattern will ensure that your finished results will be pleasing.

In the UK in recent years the teaching of handwriting in schools has been somewhat chaotic. The proponents of free expression, who claim that Italic script is too uniform and prescriptive, believe that all children will finish up with handwriting that is stereotypical. I disagree because, for me, Italic is the most natural way of making words. Walking is an equally uniform activity which we all do in the same manner; yet everybody's walk is individual; indeed, we can usually recognise our friends quite easily from behind!

Try to make your handwritten letters both to the calligraphic pattern and with rhythm and flow. Practise as before, but putting an 'm' between the other letters so as best to emphasise the bouncing nature of the rhythm – ambmcmdmem etc., see **fig 48**. The illustration also includes some practice words (including my eccentric spelling of antirrhinum) especially selected to help you to develop a freely written style.

You will find that your individualism will assert itself. You cannot avoid this. Forgery is difficult, except where people adopt quirky mannerisms such as little circles over the 'i', exaggerated loops, reverse strokes on descenders, etc. To use the walking analogy again, these affectations remind me of fashion models mincing down the catwalk, or Olympic walkers striding round the stadium, or, at worst, the John Cleese Ministry of Silly Walks sketch! Who wants to write like that?

My finished piece for you to attempt here is a sample of

am bm cm dm em
fm gm hm im jm
km lm nm om pm
qm rm sm tm um
vm wm xm ym zm
minimum implicit
irises antirhinums
michaelmas daisy
foxgloves and zinnia

Fig 48.

tongue-in-cheek, somewhat black humour by the 18th century satirist Jonathan Swift. This comes from his essay entitled 'A Modest Proposal for Preventing the Children of Ireland being a Burden to their Parents or Country'. There are quite a lot of letters in it so there is plenty of opportunity to practise the ligatures, and to get to know both those letters which will join easily, and those which are best left separate. I have written it with a Mitchell No. 3 nib. If you use the same it should fit on an A4 piece of paper, see **fig 49**.

It should be recognised that there is no dogmatic boundary between informal Italic calligraphy and Cursive Italic handwriting, only infinite shades. Rather, it has more to do with intent, context, materials and temperament.

Cursive Capitals

Capitals to accompany Cursive Italic are generally identical with those given earlier for Formal Italic; you will find their forms from page 73. As capitals are used few and far between in normal handwriting, the slowing down aspect is of no great consequence.

In **fig 50** I have given some 'Swash' versions which are rather decorative. Many people like to add a little embellishment to the initial letters in their names for instance. However, as a general rule, never write whole words in flourished capitals; they can be very difficult to read. Nor should you let the flourishes overpower the essential form of the letters. The flourishes should simply be additions or extensions to clear letterforms; so, when you practise these, do the straightforward letter first, and then add the flourishes.

As always the stroke direction for flourishes, as for letters, is mainly left – right and/or top – bottom. However, as your skill with the pen develops it will become possible for you to carry out a flourish in a continuous stroke that moves in all directions. This demands a very free flowing pen (quills are ideal as they have a freer ink flow than metal nibs) and a rather light touch – especially when the pen is moving against the paper.

I have been assured by a very
knowing American of my
acquaintance in London that
a young healthy child, well-
nursed, is at a year old a most
delicious, nourishing and
wholesome food; whether
stewed, roasted, baked or boiled;
and I make no doubt that it
will equally serve in a
fricassee or a ragout.
Jonathan Swift 1667-1745

Fig 49.

Fig 50.

UNCIALS

The history and evolution of our alphabet, with its variety of styles, is like all aspects of human life – a complex, interwoven subject. To simplify this process to the bare bones we can say that Uncial letters evolved in the period 300 – 700 AD. During that period the script travelled all round the Roman Empire, including North Africa, into its final flowering as the 'Insular' Manuscripts (MSS) of Ireland and the northern counties of England.

This evolution was closely linked to the spread of Christianity; most of the magnificent books produced in this period were Bibles, Gospels and other volumes of a liturgical nature. During that four hundred years it was, like all major alphabet styles, not fixed and unchanging but fluid and adaptable, with many variations caused by influences which ranged from changing technology, through to social, political, cultural and economic factors.

At its inception, the more rounded, open forms (compared with the Roman Square Capitals which preceded it) can be seen as resulting from the natural influence of using a broad edged quill pen on smooth vellum. This combination allowed an ease of execution that is exemplified by the many instances of pen manipulation in the earlier, more formal versions where built-up serifs are made by drawing them with the corner of the nib, and by the changes of pen angle used to facilitate the making of some strokes, see **fig 51**. Incidentally, this use of the corner of the nib as a drawing tool led to the letters sometimes being referred to as 'artificial Uncials'.

The smoothness of the quill/vellum combination can be contrasted with the previous technology which was the reed pen (a harder, less flexible tool), writing on papyrus, which was also made from reeds and had a distinct horizontal and vertical 'grain' to its surface which facilitated straight lines rather than curves.

Not only was it easier to make curves on a smooth surface, it was also quicker. This economy of both time and effort has always been a significant factor in the evolution of letterforms.

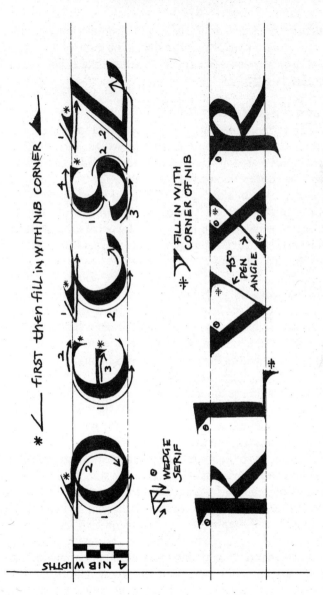

* ∠ first then fill in with nib corner ◢

◢ fill in with corner of nib

WEDGE SERIF

4 NIB WIDTHS

45° PEN ANGLE

Fig 51.

Although regarded as a majuscule (capital) letter, written between a single pair of parallel lines, you can see the beginnings of ascenders and descenders in letters like B D F G H I J K L Q R Y in **fig 52**.

Flat and Slanted Pen

Pen angle The earliest Uncials, as described above, were written with a virtually flat, zero degrees pen angle. However, this evolved into a rather more convenient and comfortable, although still rather flat, pen angle of about 20-25 degrees. You can see this trend beginning in **fig 52**, and taken further in **fig 53**. An obliquely shaped pen is helpful in making this flat angle; hence it is worth noting that the Speedball and Brause pen nibs, shown in Chapter One, are made with a slightly oblique angle at the tip.

Height As with all alphabets, there is no fixed height. However, analysis of historic MSS will show that Uncials are generally rather heavy letters ranging in height between 3 and 5 nib widths. The slanted pen variants tend to be the rather lighter versions within this range, see **figs 52** and **53**.

Speed Uncials are essentially formal, upright letters used for important documents and books. As such they were generally written carefully and relatively slowly. The pen manipulation mentioned earlier also tends to be a slowing factor. However, there are instances to be found in ancient MSS where speed has exerted its natural influence and caused a very slight forward tilt, and even vestiges of branching arches in relevant letters such as H M U Y etc. These characteristics can be exploited in contemporary calligraphy.

Size As the word Uncial derives from the Latin word for 'inch', it is sometimes suggested that these letters got their name from being written relatively large. However, there are numerous examples of their being written quite small in many books. Nowadays they do tend to be used for titles rather than

Fig 52.

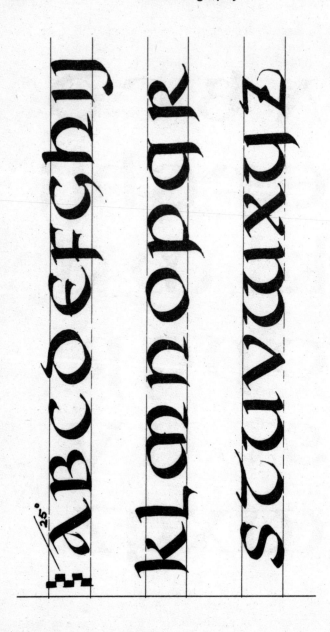

Fig 53.

text, and they do lend themselves to quite large scale usage, as in posters, etc.

Once you have tried both versions – the flat and the slanted pen types – you will appreciate why scribes today tend to prefer the latter. The reason is simply that it can be written more freely and fluently. There is a real difference between writing and drawing; so it is not really surprising to learn that, historically, the scribes and the illuminators were usually different craftsmen. The sheer quantity of writing in a Bible, for instance, normally necessitated the use of several scribes in the making of one copy. An example of this is the famous 'Book of Kells' written in about 600 AD, which took the combined efforts of three different scribes.

In early MSS which were written in Latin, it is quite common to find an interlinear 'gloss' in another language. This translation was probably added later when national languages became more prevalent. For instance, English did not really come into being, as a written language, until Chaucer's time – in the 15th century.

In this practice lies the origin of the adage '*reading between the lines*' in order to gain the true, if hidden, meaning of a message or text.

The contrast between formal, upright, open letters (like Uncials), with the more informal, compressed, sloping texture of say, Italics, creates a design device that can be exploited to telling effect in contemporary calligraphy, see **fig 54**.

This exemplar, which I have offered for you to copy, spells out a sentiment which ought, even though it is more than two thousand years old, to be on the desks of all politicians. It is an example of the slanted pen type, with an interlinear gloss in Italic as a contrast to the open Uncials.

Half Uncials

These are sometimes known as 'Semi-Uncials' and 'Insular Half Uncials'. Concurrent with the inception and evolution of the Uncial script can be seen the development of this letter-form. It was once thought that these letters formed an interim

SALUS POPULI

"the good of the people is the chief law" from

SUPREMA EST

De Legibus by Marcus Tullius Cicero 106–43BC

LEX—CICERO

Fig 54.

script between Uncials and the Carolingian minuscule, of the 8th century, which is now regarded as the first true minuscule (or lower case) letterform. However, the scholars that study ancient MSS now agree that it has somewhat different origins.

Although this interim status may not historically be correct, in visual terms it does appear to form a bridge between the two scripts. Uncials clearly come across as majuscule (capital) letters. Half Uncials are much more akin to minuscules, with more, as well as longer, ascenders and descenders. The similar and more uniform shapes, which are a characteristic of almost all minuscule scripts, are also apparent.

The Half Uncial is, generally, a simpler and quicker letter to write; there is not the manipulation and drawing with the nib that is to be found in the Uncial letters. However, some versions still show 'built up' serifs, either wedge or club shaped.

Pen Angle Like Uncials this is quite flat, with variations between 5 – 20 degrees seen in historic versions. As most right handed people naturally hold a broad edged pen at a slight angle, it is normally easier to write with a slight slant to the pen angle. **Fig 55** was done like this, and it also shows the sequence and direction of writing the basic shapes which, it will be noticed, are essentially the same as those for the scripts already encountered.

Most people will find, with a little experience, the angle with which they are most comfortable. That is why I am hesitant to prescribe a very definite one. However, do remember that the Half Uncial, like the Uncial, is a script that needs an essentially 'flattish' angle to ensure the wide, open roundness that is its primary characteristic.

Height Like Uncials, Half Uncials tend to be quite heavy, with an 'x height' of 3–4 nib widths, and with ascenders/descenders up to double that. My illustrations show some variety of weight, in order to demonstrate that there is room for personal interpretation.

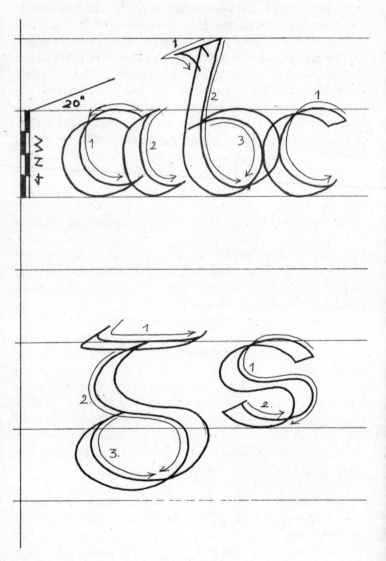

Fig 55.

Form/Shape Quite round, open shapes are the basis of most letters in this alphabet, see **figs 56** and **57**. As you can see, there are some archaic letters which are not normally used today, such as the 'g', and especially the somewhat rounded type of 'l' and 'b', and the upside down 's' (wherein the top bowl is larger than the bottom one). These unusual letters give this script its unique flavour, one which is seen as 'Irish', and used as such in advertising for many things of Irish origin. This impression probably stems from MSS such as the aforementioned Book of Kells and the influence of Irish Christian Missionaries in the north of the British Isles. The Half Uncial alphabet illustrated here shows what is essentially a historic version.

Size The original Half Uncial script was primarily a book hand, as demonstrated so magnificently by the volumes of the Kells, Durrow, Lindisfarne and St Chad gospels. This usage demanded a small size. Nowadays very few books are hand-written; and so today's use is more normally that of a 'display' script, restricted to titles, headlines, or other short phrases etc., rather than for long passages of text.

Speed Any script used at all extensively, however, must still be capable of being written freely and fluently. The writing speed of any script is governed by its complexity which, in turn, is determined by the number of separate strokes, and the manner in which the strokes are made.

The number of strokes can be reduced by pushing the pen as much as possible. As mentioned previously (on page 83 for Cursive Italic minuscules), this is very much a personal thing and should be allowed to develop naturally, as you become more proficient. By avoiding the pen manipulation of 'draw-ing' and changes of pen angle, such as are required for parts of Uncial letterforms, most scripts can be written freely and rhythmically.

The fewer and simpler shapes help the concept of 'family groups' to be observed. These are ifjltb ceos adgq uwy hmnprk vxz, see **fig 58**. As always there are a few awkward letters that

Fig 56.

nopqrst
uvwxyz

Fig 57.

ifj ltb ceos

adgg aaay

hmnprkvxz

Fig 58.

don't fit too well. For example, it must be realised that some letters, such as juw, did not exist in the time when Half Uncials originated. They have since had to be invented to fit in as well as possible. The examples given in this illustration have been 'modernised' to make them more suitable for today's usage; but they still demonstrate the primary characteristics of Half Uncials, being those of a round, open letterform, written with a flattish pen angle.

When you have practised your 'scales' (see page 40), by doing the family groups and the alphabetic sentences, try the example I've given here in **fig 59**. It's another piece by that famous poetic family 'Anonymous'; this time by an Irish member of that richly talented fraternity. If you look back you will notice, among the illustrations for this letterform, the occasional use of overlaps of some of the strokes, especially on adjacent juxtaposed curves as in 'peace' (where the pe pair might be overlapped), or in 'food' (where the two o's could be). This device was widely used to save on time and materials, as was the use of abbreviations. Nowadays, we tend to reserve abbreviations for common and/or unimportant words such as etc., but the scribes of old would shorten even the most important words in a text. This can be seen most clearly in the aforementioned Gospel Books, with the common use of 'Dni' for Domini (the Latin word for God)! You can't find a much more important word than God in a Bible.

GOTHIC ALPHABETS

The extent of the Gothic period can be simplified as falling between 1000–1400 AD; the era between the end of the Carolingian Empire and the advent of the Renaissance.

Unlike the previous scripts, which found their way and were generally used across much of the Western world, Gothic scripts take on more localised, national characteristics.

In order to condense this long historical period, we can observe simply that, in the North-Western areas of Europe, the script was angular and dense and made up almost entirely of straight lines. (This is the script that most people call 'Old

God's Praises

only a fool
would fail,
to praise God
in his might;
when tiny
mindless birds,
praise him
in their flight.

Fig 59.

English' or 'Black Letter'.) However, in the South-Eastern areas of Europe, the Gothic scripts used tended to be softer and less dense in texture, and distinguished by a general use of curved strokes.

Just to add to the confusion, even within a single country (most notably Germany where the use of Gothic alphabets persisted until the 20th century), there were stylistic variants known as Schwabacher and Fraktur. As if to cap it all, there was also a cursive variant, which differed somewhat depending on which country you were in, which was sometimes referred to as 'the Secretary Hand'.

It is rather ironic that this period, which is often referred to as 'The Golden Age of Calligraphy and Illumination', mainly used scripts which have fallen into oblivion since the Renaissance. As aforementioned, only the Germans continued to use their versions of the Gothic alphabet, and they did so until the 1930's, when a certain Herr Adolph Hitler decreed that the Roman letter was to be used as the 'official' alphabet throughout Germany.

Like the Uncials, the use of Gothic scripts is today generally reserved for those occasions when the flavour and feeling of that historical style is necessary to express the words properly. Rich, dense texture with decorative details, often combined with the use of gold and rich colours, immediately conjure up the Gothic age.

It must be said that these scripts are not easily read, and that they therefore should be used with discretion. Because the capitals are really over the top in their use of decorative devices, they should only be used as initial letters, never for complete words. Incidentally, this is the only absolute rule I observe in calligraphy.

Despite there being several versions of this generic type of letter, there are certain characteristics which are common to most Gothic scripts; however, remember that all are 'suggestions' and thus are capable of some degree of personal interpretation.

Pen Angle In general, this is steepish at about 40-50 degrees. The lesser angle gives a slight emphasis to the verticals, which enhances the strong upright texture of the more angular variants, such as Textura/Quadrata/Precissus, which only differ in minor details. In the top line of **fig 60** an archetypal Quadrata can be seen.

This angle is maintained in the other two variants also shown, but notice that the internal space is a little greater in these versions. The middle line shows a 'modernised' version based on the curvilinear strokes of Schwabacher. The bottom line demonstrates a 'hybrid' of the two using both angular and curvilinear strokes, as was the case with Fraktur.

Height This may vary between 5 and 6 nib widths 'x height' for normal purposes. The rich, dense texture, which is so characteristic of this script, is created by the narrow, condensed letters spaced at extremely regular intervals.

Form/Shape The essential shape varies considerably from version to version but, in general, this is a condensed letterform; one, therefore, which came into being as a response to the need to make books more economically.

Eventually, in Germany in about 1450, this need was totally satisfied by the invention of movable metal type and the printing press. It is worth noting that the very earliest printed books were in type which was Gothic in form; even though this was very quickly superseded by the use of Roman type similar to the letters that you are now reading.

It has been calculated that it took about 300 calf (or sheep) skins to make enough vellum (or parchment) for a Bible. That's an awful lot of dead beasts with which to cope. I wonder if scribes lived on a diet that consisted entirely of lamb and beef, coming from the principal animals concerned?

Needless to say, in those days there was strong pressure to get as many letters as possible in a line of writing. Laterally compressed letters like Gothic therefore found favour and, certainly, they were a great improvement in this respect.

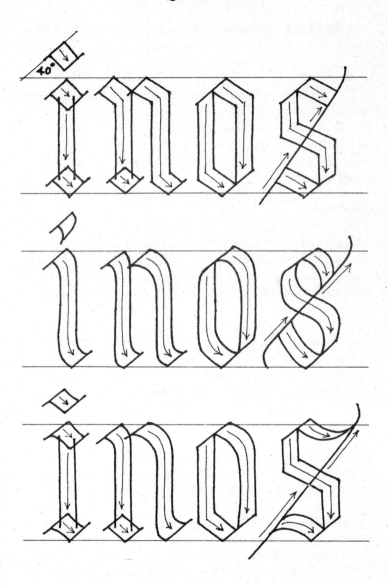

Fig 60.

In **fig 61** you can see all of the main variants of the Gothic letterforms:

Rotunda
1. This is the version found historically in Southern Europe, mainly in Spain and Italy. The letter 'o' is rather open but slightly angular, as is the 's', whereas most of the other letters are quite narrow. Notice how some of the stems have a flat bottom edge, as shown in the 'f' and 'i'; this is made with the corner of your pen.

Quadrata
2. This example, which was prevalent in North Western Europe, shows the sharply angular form normally known as 'Quadrata'. Note the extremely regular spacing of the stems, which give an impression of iron railings. The twirls at the top of some strokes, and in the 'a' and 'c' etc., are made with the corner of the pen.

Precissus/Schwabacher
3. This style is almost totally curvilinear. It has origins in the historic versions known as 'Precissus'; traces of 'Schwabacher' can be seen too. These forms were to be found in both Britain and Germany.

Fraktur
4. This relates to the version of Gothic known as 'Fraktur'. It exhibits elements of both the angular and curvilinear types. Most letters have some of both in their make-up.

Batarde
5. This variant is derived from several historic versions generally known as 'Batarde'. In it can also be seen links with the Cursive and Secretary Hands of the period. It has the slight forward slope that is indicative of all cursive scripts. These semi-cursive scripts can be found in MSS from all over Europe. They were normally reserved for secular, commercial

Fig 61.

purposes, rather than liturgical documents.

It is interesting to note that all five versions have taken up similar amounts of space; all show the rich dense texture which is characteristic of condensed scripts.

Of interest here is that the naming of scripts is an ongoing and apparently irreconcilable discussion among scholars. From a calligrapher's point of view names are simply a convenience; the important aspect is to be clear as to the essential characteristics which make any script distinct.

Size When you visit a museum to see MSS, you will find Gothic scripts in the widest imaginable range of sizes. These range from the tiny versions in the exquisitely written Books of Hours, made for cultured ladies, to the huge Antiphonals in which scripts were written extra large so that they could be read by the whole choir, in a church or cathedral, as its members stood in a semi-circle around a lectern.

Speed The most influential factor which influences the speed at which a particular script can be written is probably the number of pen lifts that are necessary. Angular Gothic scripts are the most demanding in this respect; for instance, the Quadrata letter 'i' needs four separate strokes (including the dot). When made by a highly skilled scribe these pen lifts will be almost imperceptible, but they will still be a slowing factor.

Construction (By which I mean the way in which the parts of a letter are joined together.) I make a special point of this aspect in the angular versions because it has a very significant effect on the overall appearance of your finished work. Basically, you must distinguish between a single stroke letter, as in 'i' or 'j', and the first stroke of a multi-stroke letter, as in 'n' or 'm', see **fig 62**.

A. Shows that the lozenge shapes which form the ends of the stroke are separate strokes and protrude outside of the edge of the down stroke.

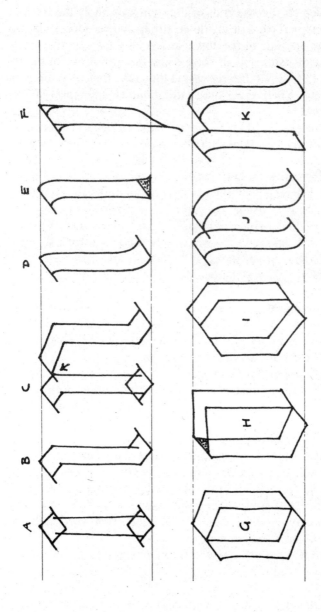

Fig 62.

B. Depicts that the ends of the stem are simply the 'lead in' and 'lead out' parts of the down stroke and, as such, only protrude on one side of the down stroke.

C. Demonstrates both versions on the first stroke of the letter 'n'; this allows the arch just to touch the stem with the point (arrowed), which gives the sharpest and clearest form of construction.

D. Illustrates a simple version of the more curved form.

E. Portrays a variant with a flat base which is formed by filling in with the corner of your pen's nib.

F. Exemplifies a 'built up serif' at the start of the stem of a 'j', and a dragged out point at the bottom of the stem, which is also formed by turning the pen on its left corner as it is pulled below the line. (This technique of lifting one corner of the nib as you continue the stroke is widely used by scribes to make the little decorative 'flicks' at the ends of many strokes. Don't force them – they will come naturally as you gain in skill and confidence.)

G. Displays the best form of arch construction, inasmuch as the point of the arch just touches the upright stem. This maximises the contrast of thick/thin which, in turn, enhances the true 'calligraphic' effect. The same type of junction can be seen at the bottom of this letter.

As aforementioned, you must be careful about making the arches in order to achieve the type of effect that you want. Your arches should exhibit a consistent method of construction in any single piece of work.

H. Illustrates an overlap of the two strokes. This gives a very strong junction and it was a favourite form of the late Rudolph Koch, the German lettering artist who was one of the finest practitioners of Gothic lettering in the 20th century.

I. By way of contrast, shows the rather weak version that is seen in a number of contemporary Gothic typefaces.

J. and **K**. Emphasise how this difference can equally mar the curved versions.

Remember that it is your pen angle that is normally kept

constant whereas the angle of the strokes may be varied, see **fig 63**. This aspect is one that has been much exploited in contemporary usage, and it, too, can be seen at its best in the calligraphy of Rudolph Koch.

In the Gothic exemplars I have made for you thus far, the emphasis has centred on the vertical strokes (especially in the angular versions). Such consistency of uniformly angled strokes can be deliberately avoided, however. Then the whole impression becomes much more lively and dramatic. This is a very useful design device that can be exploited when needed. **Fig 63** shows just how much difference it can make.

Family Groups Gothic scripts are generally more uniform than almost any other style. This makes them ideal subjects upon which to base another important concept in the design and construction of an alphabet.

Type designers, who create alphabets for us all to use, have developed a system whereby certain key letters are made first. The rest of the alphabet, in that particular style, is then derived from those letters. These key letters are o h v.

Firstly, 'o' establishes the basic shape or form, from which can be made the letters cesqbpdag.

Secondly, 'h' provides the model for klmnurijft (and sometimes of '*a*'). This letter *also signals* the attitude (upright/slant), height, weight and finish (serifs) of the stems, together with the construction (how the arches are linked to the stems).

Finally, the remaining letters, wxyz, which are composed mainly of diagonal strokes, are related to those of the 'v'.

I call my interpretation of this method the OHV system. **Figures 64 – 69** show how this works with a number of variants of the Gothic scripts.

The first version, **fig 64**, shows the method in use with the 'Mediterranean' style known as Rotunda, with the rather open 'o' form, the somewhat narrow 'h', and a 'v' that is balanced between the other two letters. The final character in the second line is a 'z', and at the end of the bottom line are shown an

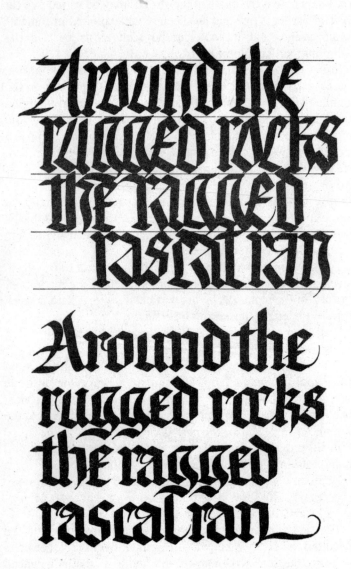

Fig 63.

Fig 64.

alternative version of 'x' and an archaic type of 'r'.

The contrast in widths between the top line of letters and the middle line is a characteristic with this alphabet. Also note the 'flat feet' on the hmni etc.; this finish is made by drawing with the corner of the pen.

In the next example, **fig 65**, is shown the same method in use with a very angular version. Notice the very narrow internal space within the 'o', which is little more than a single stroke in width. This characteristic is followed through the alphabet generally and is also used to create the space between the letters. The diagonal letters based on the 'v' are made to have a similarly restricted amount of space within them. This factor, whereby you try to get an even texture to the writing by creating equal space within and between letters, is fundamental to good calligraphy.

Incidentally, the final letter in the middle line is 'z' (eventually your eye will 'tune in' to the idiosyncratic nature of Gothic lettering). At the end of the third line is shown an 'ampersand' (&) that fits in with this alphabet. This is the character that letterers have fun with; more or less anything goes!

The next example, **fig 66**, is based on the original 'Fraktur' model of Gothic script; and it shows how each letter (except the 'i') is made partly of an angular stroke and partly of a curved stroke. In this way the extreme uniformity of the angular version is tempered by the curves of the softer scripts.

The forked serifs at the tops of the ascenders, the tapering points on the descenders of qp and 'y', and the final strokes of the hkmn, are all made with the corner of the pen. Of course it will take you a little practice to master all these finishing touches.

In all Gothic scripts there are alternative letterforms. You will have noticed in this example that there are two 'a's, 'w's 'r's and 'x's from which to choose. I have also included an appropriate form of the ampersand (&) to use with some of the scripts. Have some fun creating the missing ones.

Fig 65.

Fig 66.

Modernised and Cursive Versions

The basic principles of Gothic lettering can be seen in a 'modern' interpretation of the letters, see **fig 67**. This one uses a similar form to that of the Compressed Round Hand, but makes it taller and narrower. Again, I have put in alternative letters and an appropriate ampersand.

As in any period, there is a more cursive script to be found. Historically, this may be called 'Gothic Cursive', 'Batarde' or, occasionally, the 'Secretary Hand'. It varied widely from place to place and could sometimes be very difficult to read if you were unfamiliar with it. In my exemplar, **fig 68**, I have omitted the very archaic versions of 'h' and the long and short 's's that were common to the period. I hope, therefore, that the result gives the flavour of this script without being too illegible. This is an ideal script for any extracts from the works of Chaucer and his contemporaries (14th century), as it was the everyday script of that time and, as such, was written very freely, often with ligatures.

Finally, see **fig 69**, where I have included a most handsome variant originally evolved by the famous calligrapher Edward Johnston (1872-1944), who described it as a 'Gothicised Italic'. He used it for most of his work in the latter part of his life, and even based his handwriting on the same principles. It can be written quite quickly and rhythmically, and gives a very rich and decorative appearance to the page when *en masse*.

As I have used the sayings and precepts of Johnston throughout this book, here is one more: *'We should study the best historic scripts, and from them breed new varieties'*. Edward Johnston was adamant that, like all true craftsmen, we should live and work in the manner and spirit of our age. For him it was not good enough simply to copy old scripts; we should also analyse them and develop fresh variants for our own use.

My finished piece of an upright, angular Gothic script for you to attempt is a quote in German: *'O Gott dass Brot so tuer ist, und Fleisch und Blut so billig'*. Shown in **fig 70**, this

Fig 67.

Fig 68.

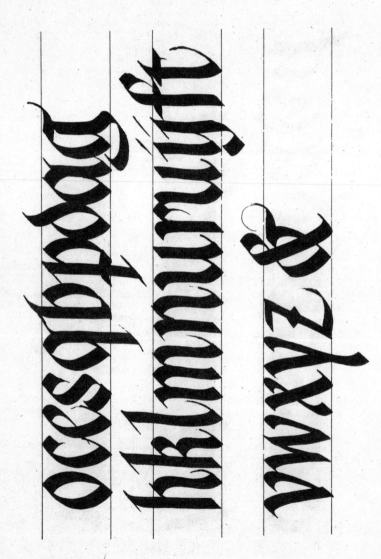

Fig 69.

translates as 'O God the bread is so dear, and flesh and blood so cheap', which is a quote from the 'The song of the shirt' written by Thomas Hood in the early part of the 19th century. The quotation was given to me by Albert Schmaltz, a German calligrapher who wrote a very fine, free Gothic script. My version shows the German convention of capitalising the initial letters of all nouns. This distinctive use of wide, open, round and decorative capital letters breaks up the iron railings effect of the minuscules, and provides a strong contrast to their dense, vertical texture.

It is worth noting that the space between the lines is quite small, and that the height/length of the ascenders/descenders is only one and a half nib widths. When very condensed letters are being used they create, across the page, very strong linear bands of black/white texture which need only a minimum amount of white space to separate them visually. The capitals are quite short as well, relying on their other qualities for emphasis.

In the top line the strange character before the capital B is a use of the long/short 's' which was quite common in the Gothic period; the convention was to have a long 's' (like an 'f') within a word, and a short 's' at the end of a word. When a word ended in a double 's', then the two characters were combined together. Needless to say, this was not necessarily observed on all occasions. However, when the printer came on the scene these conventions, which were previously at the whim of the scribe, became rigid rules.

To give you the opportunity to try a 'Batarde' style I have selected a few lines (in his own spelling!) from Chaucer's 'Parlement of Foules'. Little did he know, perhaps, how aptly his thoughts might also apply to the learning of calligraphy... see **fig 71**.

This version is rather heavy, being only 3 nib widths in 'x height', and it has quite a pronounced forward slant. Notice the different form of 'r' in the word 'sharp' in the final line. This is a fairly common form in most of the Gothic scripts.

My final piece for you to attempt is Edward Johnston's well

Fig 70.

The lyfe so short · The
craft so long to lerne;
Th'assay so hard, so
sharp the conquerynge.

Fig 71.

known maxim about calligraphy, see **fig 72**. It is the over riding concept behind this book, and I am indebted to his enormous wisdom in developing most of the underlying principles that inform my teaching. This exemplar is written in my version of his 'Gothicised Italic' featured in **fig 69**. These modernised forms of Gothic lettering, being very economical of space and energy, lend themselves to works which have a lot of letters to fit into a relatively small space.

Gothic Capitals

The capitals used with the minuscule scripts vary considerably throughout the period when Gothic was the general style in use. As mentioned before, the main need is to create letters which give a strong contrast to the dense texture and vertical emphasis of the minuscules.

The capitals used in everyday MSS were made with the same pen as the script. They were wide, round and very decorative, with much use of 'double stroking' (as in the S) and embellishments to the vertical parts in the form of hooks or lozenge shapes, see **fig 73**. One of their major faults is that they are not as well differentiated as Roman capitals; it is often easy to confuse E and F, or C and G for instance. However, it should be understood that much of our ability to recognise words is due to context so, as long as you only use these letters for initials, their illegibility is not normally a problem.

In more important documents, and remember fine books were the status symbols of their time, the norm was to use drawn and painted letters based on the Roman, Versal and Lombardic alphabets. (For the latter two, see below.) These were often made very large and historiated with scenes with from the excerpt being written. For instance the passage in the Bible describing the 'Adoration of the Magi' might have had the initial letter filled with a miniature painting of the Nativity scene.

This form of emphasis is rightly called 'Illumination'. Its attractions are both visual and intellectual, inasmuch as it tells part of the story in pictures, and also that the use of strong colours, especially burnished (polished) gold leaf, brightens or

"Our aim should be to make good letters & arrange them well"

Fig 72.

Fig 73.

illumines the page. The art of illumination lies outside of the scope of this book.

VERSALS

The Versal letter is essentially a simple Roman capital, drawn with a narrow pen or a brush, rather than written with a broad pen. In this way an 'I' takes 4 strokes – left edge/right edge then top/bottom edges – rather than a single movement of a broad pen, see **fig 74**.

It does take a considerable amount of drawing skill to make these letters successfully. For this reason they are often first drawn separately with a pencil, and then transferred to the page by the use of 'tracing down' paper. This is similar to duplicating paper and is put between your initial drawing and your final surface; then you trace over your drawing with a hard pencil (such as 2H), which transfers the image down onto the surface. Finally, this image is then painted in with a brush. These letters would normally be made in colour, so the final painting would be carried out in Designers' Gouache (a form of opaque watercolour available in most art shops). An ideal tool for this painting would be a sable or synthetic watercolour brush, with longer than usual hair rather than the short 'artists' type.

This three stage process is much more controllable than working with pen and ink directly on to the final surface.

Versals are generally quite light in weight. Observe that the stems are not simple straight lines, but have a slight concavity which is known as 'entasis'. The purpose of this refinement is to make the stem a visually more elegant shape. It derives from the slight curvature found on the columns in classical architecture, which was likewise introduced to enhance their appearance.

LOMBARDIC CAPITALS

These can be traced directly back to Versals, and may be described as exaggerated Versals with Uncial tendencies (see, for example, Uncial E and M in **fig 54**). Unlike Versals they are

Fig 74.

generally rather heavy, with strong contrast between the thick and thin strokes being a dominant feature, see **figs 75** and **76**. They are sometimes decorated with patterns and textures, both in and around the letters, in their illuminated versions.

In human terms Lombardic capitals are the extrovert, 'life and soul of the party' type characters of the lettering world. One of the common characteristics of this 'over the top' style is the tendency to enclose the space within the letters – as can be seen in the two exemplars – in the letters A C E N M etc.

As with Versals, these Lombardic letterforms are best kept for initials, titles and the like. My exemplars were made using the same method as the Versal **fig 74**, by drawing the letters first on thin paper, then transferring them onto cartridge paper with the 'tracing down' paper, then outlining them with a fine brush, and then filling in with a broader brush.

Incidentally, when working for reproduction it is best to work either with black gouache with some added gum Arabic, or with waterproof Indian ink, rather than the NON waterproof ink used for calligraphy. When using waterproof materials, be sure to wash out your brushes/pens thoroughly, using warm soapy water, immediately after finishing with them. Pens can be 'rescued' if you let paint or ink dry in them, but brushes will never be the same again.

COPPERPLATE SCRIPT

This was the final style of letter to evolve from handwriting, rather than printing; however, printing did have an important influence on its development. Indeed, it is true to say that this style is the first example of the calligrapher copying the printer, rather than the other way round.

Again, to put its historical background in very simplified terms, the Copperplate style evolved from the interaction between scribes and early printing technology.

When movable metal type was invented by Johannes Gutenberg in about 1450 AD, scribes were made redundant as the makers of books. For a while they survived by writing the title pages of printed books, and inscribing initial letters in

ABCDE
FGHIJK
LNOP

Fig 75.

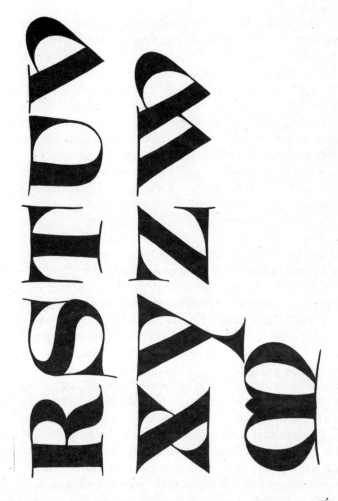

Fig 76.

colours. This was more economic than setting metal type to print perhaps just one red letter on a page. Also, they continued with their work in the offices of the Church authorities and of merchants.

The easier access to books afforded by printing them brought about an immediate increase in literacy. When people learned to read they next wanted to learn to write; so, 'Hey Presto' the scribes became, instead, writing masters. The need for copy books from which their students could work led the scribes to commission the reproduction of these books relying on the expertise of wood engravers. Examples of such mass produced copy books are still in existence, and can be seen in major museums and libraries. Inspection of these books shows that, while the general impression given by a broad edged pen was quite faithfully preserved, the general quality seems to be a little clumsy when compared with the original versions written with a quill pen on vellum or parchment.

However, at the same time the 'intaglio' printing process was invented. This method involved engraving the image into a copper printing plate, using a very sharp tool known as a burin. This technique gives an exquisitely fine and controlled line, and enabled the scribe to issue new copy books that exhibited the technical finesse that was also to be seen in fine calligraphy. A comparison of copy books printed from wood block engraving, such as those shown in 'Three Classics of Italian Calligraphy' by Oscar Ogg, with the examples of copperplate engraving as shown in 'The Universal Penman' published by the Victoria & Albert Museum, demonstrates this difference much more clearly than I can describe it.

Unfortunately, the nature of intaglio copperplate engraving did not allow the exact replication of what was fundamentally an Italic letter, made with a broad edged pen. However, the scribes soon realised that if they simply recut their quills to a point, then they were able easily to imitate the revised letter-forms seen in the new copy books, see **fig 77**. Thus was born the Copperplate Script.

The essential difference between Italic and Copperplate

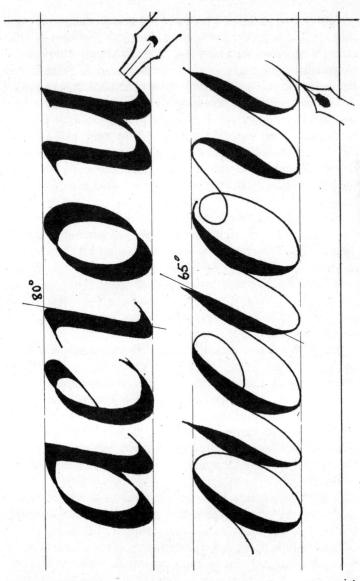

Fig 77.

scripts is that, in Italic, a broad edged pen produces thick and thin strokes simply by changing direction. Because of this, changes of stroke thickness can be really abrupt. However, in Copperplate, to make a thick stroke with a pointed pen demands the use of pressure when the nib is being pulled downwards, and then releasing the pressure to make a fine hairline on the upstroke. This application and release of pressure has to be effected gradually. In this manner, the characteristic stroke in Copperplate writing exhibits a quite different, gradual change in stroke thickness, compared with the abrupt change effected by the broad edged pen, as seen in Italic.

Incidentally, all of the three sizes, seen in my exemplar for this script in **fig 79**, were written with the same nib. I simply used more or less pressure to alter the weight (thickness) of the down strokes. Because of this, the concept of height expressed in nib widths, and also the notion of 'pen angle', have no meaning in the context of Copperplate calligraphy. It is true to say that it is, *in most respects*, totally different from writing with a broad edged pen.

In **fig 77** you can view the main differences between Italic and Copperplate scripts. Although the maximum stroke thickness is roughly the same in both, the general appearance is quite different. Firstly, the slope of Copperplate is greater and, secondly, there is much more thin stroke visible. These factors combine to give the impression of a lighter script with pronounced hairlines. Finally, the letters are also ligatured together, which makes it much more cursive, like normal handwriting.

Two characteristics, however, continue to be shared. They are firstly, the lateral compression: both scripts are somewhat narrow. Secondly, they each retain a similar oval shape.

There is little doubt that repeated application/release of pressure, as described above for Copperplate, was neither so ergonomically efficient nor as relaxed as using the slightly blunt, broad edged pen used for Italic. I fear it must have been a real source of 'writer's cramp' for a clerk of the 18th/19th

centuries for whom, by popular demand, this script was an everyday requisite.

Despite this drawback, the writing of Copperplate script with a pointed nib became almost universal in its application across the UK for both private, public, and especially commercial use. In fact it was even known as 'English Round Hand' so as to contrast with the spiky script of the 'Batarde/Secretary' hands being used in most of the rest of Europe. Its appeal in modern times is much diminished, however, except perhaps in France where it is still widely used in advertising and display work.

It should be noticed that almost all of the copy books that were issued by the writing masters of that period were illustrated by engravings, not penwork. The significance of this fact is that the exemplars demonstrate the 'perfectionism' of which an engraver is capable, rather than the inconsistencies which are the human face of calligraphy. This perfectionism is especially observable in the flourishing and arabesques that are a feature of these books, and which decorate and embellish their texts. This can be seen to great effect in 'The Universal Penman' mentioned above.

There was a great deal of competition between the various writing masters. Their books were often saying *'Hey! Look how fantastic I am'*. But, in truth, it was more often the engraver that was the fantastic craftsman.

In simple terms Copperplate can be likened to normal Italic handwriting, albeit however, done with a pointed pen, with definite pressure on all the downstrokes, and with ligatures between the letters wherever they occur naturally.

Before commencing the detailed information of how to write Copperplate script I must offer some advice on nibs. Firstly, buy them from a specialist supplier such as Philip Poole (see Appendix); secondly, buy them in quantity; thirdly, buy a selection of various brands, initially, so that you can decide which you prefer by 'trial and error'. There is a wide variety of opinion amongst 'Copperplate scriveners' as to which is the best type and brand, so be sure to buy those that

suit you.

You will also see from **fig 77** that the pointed pen is held at a very different angle when compared with the square cut pen. Most writers will need to turn their paper to a rather pronounced angle to facilitate the maintenance of the much more sloped letters that are characteristic of this style. Experimentation will determine the exact angle that personally you need.

The ductus (pathway) of the pen, shown by the arrowed lines in **fig 77**, demonstrates that the pen is moved upwards quite a lot. To enable this with a very sharp, pointed nib the pen has to be held very lightly on these upstrokes. You also have to learn, as you 'bounce' off the baseline, to change from the definite pressure of the down stroke to the very gentle touch of the upwards push of the ligatures. This is how you achieve the very fine hairlines which are another of the script's essential characteristics.

Even though the special nibs which are necessary for Copperplate are made from tempered steel, the continuous application/release of pressure causes them to 'split' after relatively little use. (I used a new nib for each of the Copperplate illustrations for instance.) It was the invention of the steel nib which allowed this style to become so universal; and it was the short life of the nibs which enabled the manufacturers to make and sell them in millions in the 18th/19th centuries. Indeed, parts of the Midlands owed much of their prosperity to the advent of Copperplate script and the consequent, insatiable demand for nibs that resulted from it.

The regular on/off pressure and the similarity of shapes are conducive to rhythmical writing. So the exercises that you have done previously – the family groups and the alphabet with an 'n' written alternately – will help you to get into the swing of the script quite quickly, see **fig 78**. Notice that, in this script, there is a unique form of 'p', and there are two distinct forms of 'r' to be found in this style.

The finished piece for you to attempt in Copperplate, **fig 79**, is a poem by the 17th century poet, Robert Herrick. Thus we

Aabcdefghijklmnopqrstuvwxyz

ambcndnenfngnhninjnknlnm

nonpnqnrnsntnunvnwnxnynz

Sphinx of black quartz, judge my

vows in copperplate calligraphy.

Fig 78.

Delight in Disorder

A sweet disorder in the dress
Kindles in clothes a wantonness:
A lawn about the shoulders thrown
Into a fine distraction:
An erring lace, which here and there
Enthralls the crimson stomacher:
A cuff neglectful and thereby
Ribbons to flow confusedly:
A winning wave, deserving note
In the tempestuous petticote:
A careless shoestring, in whose tie
I see a wild civility:
Do more bewitch me, than when art
Is too precise in every part.

Robert Herrick

Fig 79.

A B C D E F

G H I J K L

M N O P Q R

S T U V W X

Y Z &

1 2 3 4 5 6 7

8 9 0

Fig 80.

know that it was written during the time when Copperplate was evolving from Italic. I wonder, from what he opines, whether he was an early propagandist for the 'anything goes' fashion that has most recently become so popular! The poem might also be seen as a reaction to the extreme control that is apparent in the engraved versions of the script.

The capitals which are used with this script, see **fig 80**, are rather decorative with pronounced swirls and flourishes. This aspect may derive from the engraver's skill, or, may simply be a means of creating something visually distinct from the close packed uniformity of the lower case letters. Like the similarly decorative Gothic capitals, they should only be used singly as initial letters; used *en masse* they are almost as illegible as the Gothic versions.

3

ARRANGING YOUR
LETTERS WELL

This chapter focuses on the arrangement of good letters into visually attractive pieces of calligraphy which, when desired, are also easy to read.

When you make a mark on a surface you are engaged in graphic design. Design is an over-used word nowadays; its simple meaning is 'to make a plan'. This phrase presupposes that you know what you are trying to achieve; so let's start at the simplest level – putting letters side by side.

Letters are simply abstract symbols that represent sounds. Put into groups they can make words. Each word has a unique shape/pattern which makes it distinct from every other word; though sometimes the apparent differences between word shapes are quite small.

When we learn to read, we are memorising those shapes/ patterns; for instance, this sentence 'The **fat cat sat** on the **mat**, by the **bat** and the **hat**, to **eat** the **rat**' includes eight words, each of which is unique, but which only differs from the others by virtue of its changed initial letter.

It goes without saying that reading is a very sophisticated intellectual process. Therefore, it is essential that the calligrapher understands how to enhance the reading process with his design skills.

Letter Spacing
The spacing of letters into words, words into lines, lines into a

text has a profound influence on legibility and readability. In **fig 81** is shown a common word, properly spaced in A, and poorly spaced in B.

In A each letter has enough space to assert its own unique form, neither too much nor too little. The five letters are arranged evenly to allow the unique shape/pattern that is BINGO to be as clear as possible. To coin a phrase – *each letter is discrete (separate) but the word is concrete (cohesive)*. This concept underlies the whole task of designing a piece of writing or lettering; and also each **individual element** has to be separate (discrete) and each **group of elements** should be cohesive (concrete).

To emphasise how important this aspect is, visualise 11 people crammed into a phone box. They tend to lose their individuality in such a squashed up mass of humanity! Now spread them out over a square mile. All are separate, each having just over fifty eight acres in which to roam. However, they would each need a mobile phone to keep in touch! By way of contrast, put them onto a sports pitch where they can act as a team, each with individual skills, and you will quickly discover that, collectively, they mean much more.

In B, **fig 81**, some letters are too close IN; some letters are too far apart NG; and some just right GO. It might be read as B IN GO, or BIN GO, rather than correctly, as BINGO.

To summarise the whole thing into a single sentence I say: *'the aim of good spacing is to arrange the letters with **equal areas between** the letters; and the areas between the letters should be **similar to the areas within** the letters'*.

This rather begs the question of how to define that area because, in C, some letters have small areas within them, such as the letter B; some letters, such as O, have large areas within them; yet still others have a medium space within them, such as N. My advice is to use the letter N or 'n' (for capitals and for minuscules respectively) as a guide as to how much space to put between the letters. Thus, ignoring for this purpose the different *shapes* of areas between the letters in line A, you can see how each hatched **area** is, overall, approximately equal to the

Fig. 81.

hatched **area** of the N in line C, **fig 81**.

You will remember being advised to practise writing alphabets with an 'n' between each of the letters, in order to get the rhythm of a particular script. The N or 'n' offer a practical yardstick towards achieving a visual rhythm in the same way.

In D, the word is spaced evenly, but too tightly; whilst in E, the word is spaced too loosely, which spoils its cohesiveness.

Go back to **fig 11** to see this concept of good letter spacing in practice. There are problem pairs like LA and TZ; however, remember that the word is always more important than its individual letters. Letters only have significance when arranged into words. Try sketching, in pencil, the word SOCIETY to get this all important, even texture within your words. Beware of putting the OC too far apart, or the IE too close together; and remember it is equal **area**, not distance, that you are aiming for. My experience shows that putting adjacent, parallel strokes, such as IH or AV, too close together is the most common mistake in beginners' work.

To reinforce this introduction to designing with words, reproduce the example in **fig 82**; firstly, with no space between the lines, as I have done; then, with half a letter height between lines; and, finally, with a whole letter height between them. This exercise, incidentally, will show you that in very short lines (1–3 words) space between lines is not essential.

The spacing of minuscule scripts is much more instinctive, inasmuch as, if you are writing rhythmically, you are likely to be achieving the even texture that is the essential requirement – this by allowing the space that is within a letter 'n' between each of the downstrokes, see **fig 83**.

The essence of what you are trying to achieve is an **even visual texture**; whereby there is a consistent, textural relationship between 'figure and ground'. (This term refers to the letter [*figure*] and its surrounding space [*ground*]. It is widely used in art and design.) It is interesting to note that the word 'texture' originates from the same root as 'text': both come from the Latin verb *texere* meaning to weave.

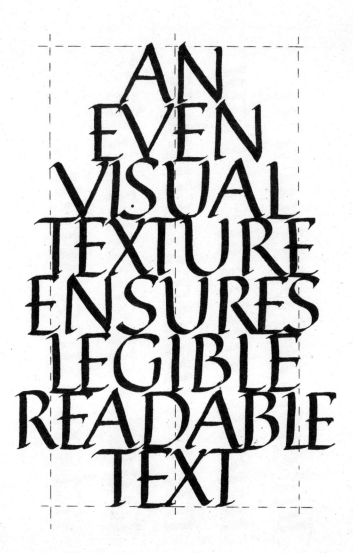

Fig. 82.

The essence of spacing
minuscule letters is for
the main downstrokes
to occur at similar inter-
vals to those within 'n'.

Fig. 83.

In **fig 82**, the lines are centred horizontally. You can achieve this by writing the words first in a solid black ink on white paper, and then placing this under your final piece of good quality paper to find the central position. Most paper used for calligraphy is slightly translucent, which allows for 'tracing' in this manner. If you really want to make life easy for yourself you can work on a 'lightbox'. These can be bought from good art and design shops.

Also notice, from **fig 84**, that the side margins are broadly similar to the top margin (on average) but that the bottom margin is slightly more. This extra space below the bottom line prevents the whole thing from looking 'bottom heavy', which is what will occur if all the margins are equal.

Word Spacing

In Roman times words were separated by a 'point', the Latin word for which is '*punctum*', and from which the idea of punctuation is derived. You may have noticed that I have used this method in several of the illustrations thus far. See **figs 16, 25, 31** etc.

Its use demonstrates how little it takes to interrupt the even, visual texture of any block of writing, so as to indicate the end of one word and the start of the next. Similarly, if you are using white space to separate words, it only needs to be slightly more than the space within the words; the Golden Rule is *just enough and no more*. The two most common mistakes in beginners' work are firstly, as previously noted, too little space between letters and, secondly, too much between words. Try writing with a dot between your words and then obliterate the dots with 'Tippex' or similar correction fluid. I think you'll be surprised.

Line length How long is a line of writing? That's not as silly a question as it may sound. Like the proverbial piece of string, it depends on what you want it for. Lines are normally measured by the word count. Try this – count the words in (a) the top line of a road sign; (b) in a single column width line

Fig. 84.

of a broadsheet newspaper; (c) any full length line in this book; and finally (d) in a full line taken from a Shakespeare sonnet.

There should be no surprise for you in finding that they are all different: 1–2 fill a road sign; 4–6 pack the newspaper column; 9–13 span across this book; in the sonnet however, it's not words but the amount of syllables that is important.

So we can only suggest some guidelines but these are based on well proven traditions that go back to the birth of the alphabet. Firstly, if the message must be read by everyone, use no more than 1–2 words per line – like STOP; DANGER; NO ENTRY; FIRE EXIT, etc.

Secondly, if you want people to be able to read something quite quickly and easily, 4–6 words per line is ample. Thirdly, for more leisurely or serious reading, 9–13 words per line is an optimum amount.

Line Spacing

To generalise, we can say that the more words there are in each line then the more space is needed between those lines. To paraphrase the words of the famous designer, Mies van de Rohe – when designing the word count to line space aspect of a text – '*more needs more, and less needs less*'. Remember however, as in all aesthetic matters, that the eye is the final judge. For instance it may be desirable to break the rules, quite deliberately, to achieve a specific effect.

The choice between capitals and minuscules has a major influence on line space. Minuscules are intrinsically easier to read *en masse* because the presence of ascenders and descenders gives clearer, more recognisable word shapes. These normally necessitate more line space than would be essential with capitals. It must also be remembered that, as the height/depth of ascenders/descenders is not a *fixed* dimension, the amount of space between lines may be influenced by several other factors. Firstly, will be the style and nature of the script in use; secondly, there is the desired overall impression (whether a dense/rich or a light/airy texture); thirdly, the num-

ber of words in a line (as previously discussed) must be considered.

Finally, however, it is essential to remember that, normally, words are meant to be read. We read in linear bands from left to right (in direction), and from top to bottom (in sequence). Line spacing, therefore, should be *just enough* to enable and enhance that process. It is also worth noting nonetheless, that calligraphy is a creative activity and, sometimes, breaking the rules can be wonderful!

With capitals we have seen that there doesn't have to be any line space in very short lines; not so with small letters.

The important thing to remember is this – there needs to be *just enough* space to allow the eye to travel along the line, without deviation to the lines above or below. You will find this normally means that the line space has to be greater than the word space.

The resolution of problems, such as ascenders and descenders clashing in consequent lines and the fitting of words within the line length, should be carried out by the production of trials and 'roughs'. This methodology of making finished pieces will be addressed later.

Margins

Now that the letters have been arranged into words, words into lines, and lines into a coherent, legible text, all that remains is to make the text fit well within the available space.

This problem immediately begs the question: what comes first, the chicken or the egg? Do you buy the paper first and then make the text fit it; or do you design your calligraphy first, and then buy some paper big enough to accommodate it?

Both methods are valid. When the work is being done to commission professionally, the scribe will normally be required to make the work fit within fixed parameters. These are often constrained by things like doing it to a size that can be photocopied if, for example, it is to be reproduced as a short run poster.

In such a case the procedure is to find the longest line in the

text (by counting letters and spaces); and then write this line in your chosen (or specified) script, with differing size nibs, until you hit upon an appropriate size. Having solved the horizontal fit, write a couple of lines to ascertain the appropriate line spacing. This can then be multiplied to find whether the number of lines will fit vertically. This 'trial and error' method may seem hit and miss and time consuming but, it is accurate and, with experience, can be surprisingly quick.

When you have sorted out the sizes, it is normal to write out a 'rough' copy on 'layout paper' (made by most major paper makers), both to make sure of the fit, and also to give yourself a rehearsal, as it were, of doing the finished piece. In an ideal world it is as well to do a 'final rough' on the same type of paper on which the final piece will be written. In this way you will get the feel of that surface before attempting the 'finished piece'. Incidentally, the word 'rough' is a euphemism; always do the work as well as you can; that way you will be practising doing good work, not rough work.

When writing something for your own pleasure, as an amateur, leisure activity, the constraints are not normally so prescriptive. But beware that paper is only made so big! Also, if you are entering work for exhibitions, there are often constraints regarding maximum sizes and acceptable materials.

We can address the question of margin sizes, firstly, by recognising that they are essential to separate the text from the background in which case the margins can be 'just enough' to allow this separation. However, certain situations, like a book page, have other constraints and conventions to follow; for example, book margins need to provide something to hold without your thumbs getting in the way. Also, margins are in a sense part of the framing, and may be adjusted to make the work more effective visually.

The use of a pair of **L**'s is very helpful in deciding just how much margin will be most effective around the work. These are simply **L** shapes, which you can make from card or mount board, in a neutral colour like black/white/grey. Place them to

Fig. 85.

form an adjustable frame, see **fig 85**, which can be moved until the best solution is arrived at.

Summary To sum up thus far on the arrangement of letters, words and lines, it can be seen that your choice of letterform has a determining influence on the basic aspects of the overall design. For example, if you choose a lightweight, open script, the space within the 'n' will determine the space between the letters; in turn, the texture of the word will influence the word spacing which, in turn, influences the line spacing. The overall texture of the whole page will affect the amount of margin space necessary to ensure clear separation of your text from the background.

Layout (and basic design aspects)
Graphic design is a vast subject in its own right and outside the scope of this book. There are, however, a few basic precepts that will enable you to make your calligraphy attractive to look at and, if necessary, functional (as for a poster).

Within the scope of the subject there are four basic, simple layouts that can be used in the majority of projects. Firstly, the centred layout as already seen in **fig 82**, wherein each line is placed symmetrically about a centre line. Secondly, the 'left ranged' version as seen in **fig 86**, whereby each line starts on a common left edge. This requires no special skills to do and I have used it in this example to emphasise the irregular line lengths.

The other two formal layouts, 'right ranged' and 'justified' are essentially typographic treatments, but they can be useful for special purposes. They both require a fair amount of planning, and the ability to write to a consistent rhythm.

The justified layout, in **fig 87**, has its origins in early manuscript books, wherein each page was written with a left ranged layout, but the 'show through' of the writing, on the reverse of the translucent vellum, gave a sense of a straight right hand edge also. With the advent of movable metal type in the 15th century, it became normal practice for printers to 'justify' the

Fig 86.

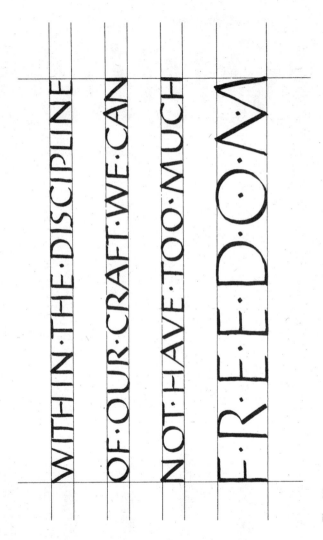

WITHIN·THE·DISCIPLINE
OF·OUR·CRAFT·WE·CAN
NOT·HAVE·TOO·MUCH
F·R·E·E·D·O·M

Fig. 87.

contrast

THE·USE·OF·A·STRONG·CONTRAST·IS·A

DESIGN·DEVICE·WHICH·CAN·BE·SEEN

IN·MANUSCRIPTS·THROUGH OUT

HISTORY·AS·WELL·AS·IN·CONTEMPORARY

GRAPHIC·DESIGN: ITS·LONGEVITY·IS·A

REFLECTION·OF·ITS·EFFECTIVENESS.

Fig. 88.

type to create a straight edge to the text on both sides.

In typography this is achieved by adjusting the word space. You will see this practice in this book. In **fig 87** notice how I have used this layout, in combination with the structure of the vertical and horizontal lines, to give added emphasis to the meaning of the words. To achieve this effect necessitated tracing from a trial version made first to ensure the exact line length.

In **fig 88**, my final exemplar, you can see a use of 'right ranged' writing, here used as a design device for enhancing the literal meaning, as well as the visual aspect, of the text.

This example also highlights the power of **contrast** in the design process. Here we must dwell on this aspect, for it is a crucial factor in the making of good calligraphy.

Earlier in this chapter I made the point that the basic meaning of the word 'design' is to make a plan. That presupposes making choices. Just to make a single mark on a sheet of paper involves choices: where to make it; what colour, size, texture; etc.

The commonest mistake that beginners make is to have too many variables in a single piece of work: too many styles, too many sizes and, although outside my scope here, too many colours as well. Unless you are very experienced, the use of more than a couple of variables becomes overwhelming and unmanageable. It is well worth restricting yourself to the minimum in the early stages.

To quote Mies van de Rohe accurately this time (see page 151), he said in his famous maxim that became the philosophy of the Modernist movement in post war art and design, *'Less is more'*.

In calligraphic terms it is generally true to say that the fewer variables you use, the more successful and effective your work is likely to be. The converse is equally true; so beware of trying to *emphasise everything*, for you will probably succeed in *emphasising nothing*! Turn over for a list of contrasting factors that you can explore – one at a time!

Size large and small	Straight and curved
Weight heavy and light	Formal and informal
Upright and slanted	Plain and textured
Horizontal and vertical	Black/white and vice versa
Capitals and minuscules	English and other languages
Structured and freeform	Wet/dry (try splashing water on)
Rough and smooth	Broad pen and pointed pen or
Traditional and	brush and so on.
experimental	

When I was a beginner I asked my mentor, the famous calligrapher Ann Hechle, why, at that time, all of her work was in black and white (with dilute ink to give grey), and she only used one style. I have never forgotten her reply: *'Firstly I don't need any more and, secondly, I haven't finished exploring the possibilities which they offer'*.

To prove to yourself the point that I am making, try writing out the same short text in three different heights with the same nib size – say 3, 4, and 5 nib widths; do this at three line spacings, and in three different 'colours' of black ink (solid black/dark grey/pale grey). That's a lot of variables. You will be surprised at how different the finished results will look.

What the previous few paragraphs have been emphasising is the use of visual dynamics. Calligraphy is inherently dynamic, especially broad edged pen writing. The contrast between the thick and thin parts of a letter is dynamic, as are the differences between the straight and curved strokes, and the very texture of lines of writing and the space between them. This last aspect is especially important.

I once took some of my work to show to the late, great calligrapher, Irene Wellington. After what seemed an endless silence as she studied it, she remarked: *'I think you are beginning to recognise that the white space is as important as the black marks!'*. This was another wonderful lesson that I have never forgotten.

Space in calligraphy is what silence is to music; sounds can

be loud or soft, brassy, reedy or twangy; they can be smooth or vibrating, high or low, melodious or discordant; but without silence they cannot exist! Space is vitally important.

4

CALLIGRAPHY FOR PERSONAL PLEASURE

Now for the exciting part, the creative bit: putting your new knowledge and skill to work. Perhaps the simplest and most direct use for calligraphy is to make your own letter heading. This is addressed (pun intended) in Chapter Five on 'Calligraphy for Reproduction'.

Meanwhile, let's start here with a greetings card. This might be a unique, 'one off' card for a very special friend; or it might be a design that could be photocopied onto coloured paper and then have some colour or glitter added afterwards. Let me take you through my thought process for such a project.

Greetings Cards

As I write this it is November, so Xmas looms. Directly I jot down the four letters forming the word XMAS, equivalent words spring to mind. I begin to see the opportunities for a strong design as, for example, in NOEL and YULE. You might also use something as simple as Christmas Greetings. Take your pick.

Now I move into TNS mode. That's not some secret code; it's simply designers' shorthand for Thumb Nail Sketches. This doodling is the very beginning of the design process. I scribble on anything that comes to hand, including the proverbial backs of envelopes. Some of my best work has started life as a sketch on a serviette in a cafe/restaurant. If you are one of the world's organised people you will always carry a notebook and pencil

Fig. 89.

for just such an event.

After doodling for half an hour (remember, the more ideas you come up with, the more likely it is that one of them will be a good one), I have usually sketched enough differing versions to suit various tastes.

Initially, the first idea to suggest itself was a broad pen, calligraphic version, using the two words 'Christmas Greetings'

in a pattern created by turning them through 90 degrees, see **fig 89.** If you are in a hurry, and you want the finished job to be truly symmetrical, you could write out the words once, and then photocopy them and do a paste-up. You could leave the square in the centre empty and add a personal message; or simply add a dab of glue followed by a sprinkling of glitter.

To reach this design I at first picked up a felt pen which had almost dried out and which gave rather an interesting effect. Then I tried a new pen, which gave a solid black and, at the same time, bled into the paper a little – giving a somewhat rough edge to the letters. Then I used both pens together, adding a finish to the dry pen letters by outlining them with a fine-tip felt pen. I realise that part of the final appearance was pure serendipity but some of the best designs often are!

The important point is that the idea developed as it went along. I didn't get it right first time. In fact I wrote it out about six times before I was happy with it. Give yourself the opportunity to make choices at every stage, and always be prepared to scrap the lot and start again!

Then my thinking returned to the fact that, for some people, Xmas is an opportunity to go OTT, completely 'over the top'. They do things they would never dare to normally; like singing out of the bath, or wearing outrageous clothes. So, I thought, let's dress up these four letters, see **fig 90**, in some OTT shapes. As I mentioned earlier Lombardic Capitals are just such an extrovert type of letterform. These letters were drawn in pencil first, and then painted in, using a thin brush and waterproof ink. You could try something similar copied onto, say, thin red or green card, and then add some decoration with gold or silver marker pens.

Again, the final piece did not happen first time round. When the square was divided into 4 equal parts the letter M did not fit very well. Altering the shapes of the four rectangles that make up the square helped by giving a taller shape for the X and S, and wider shapes for M and A; then I redrew the A to use its space more effectively. You will notice that the shape of

Fig 90.

Fig 91.

the A is much like that of a minuscule Italic A but I have drawn it with the same character as the Lombardic letters so that it does not look out of place. It's called artistic licence I'm told.

Some years ago the well known designer and lettering artist, David Quay, sent me a Christmas card with the word NOEL arranged in a square in geometric shapes. The gift was made in die-cut card so that parts of the letters were missing and, as the card was opened, the missing parts emphasised what the letters were. It was an intriguing design and, ever since then, I have played with these four letters in a square.

As a result I have come up with another version, shown by **fig 91**, carried out entirely with geometric instruments and technical pens. It demonstrates just how sophisticated is our ability to 'read' letters.

Actually, there aren't any letters in this drawing, not in the normal sense but, somehow, we see NOEL. Graphic designers love the letter O, because you can put things in it. This one has endless possibilities at Christmas tide: snowflakes, robins, holly, angels, etc., are all obvious suggestions.

When I started doodling with YULE the tail of Y was causing problems. There seemed to be a squareness evolving in the letters, so I started to emphasise the angularity. With a little more experimentation the tail of Y turned, echoed the L and found itself extended into the middle bar of the E. However, even then, there seemed to be a blandness in the design. It was not decorative enough. Then I remembered a multi-point pen I had bought years ago and, 'Hey Presto' it worked! Again, it took a lot of 'roughs' to get to the final result. In **fig 92** you can see how the final touch was to be the scribbly frame to offset the precision of all those parallel lines.

Doing this kind of calligraphy should always be fun and enjoyable. Whatever the result, you will get pleasure from doing it, and the recipients will appreciate the fact that someone took the trouble to make them something special, and didn't just pop into the nearest shop to buy it. Which reminds me, why not go into your local card shop and see what's on

Fig. 92.

offer there? Could there be a local market for some of your calligraphic greetings cards?

All of the above applies equally well to birthdays, anniversaries etc; the important thing is not to have preconceived ideas. If there is a secret of success it's to create plenty of choices and lots of ideas in your thumb nail sketches. You can

write it, draw it, paint it – whatever; there are no rules in this kind of work: or is it play?

Menu

When you next have a dinner party, or perhaps some family occasion, why not write out the menu for your guests to peruse, and excite their curiosity? As the late Laurie Lee, the author and poet, believed, anticipation is better than satiation. Alongside the menu you could have place settings, with your guests' names carefully written out. It's a visual compliment to see your name beautifully written in careful calligraphy. For a wedding you can do a guest list for the bride and groom to keep. A handwritten copy of the wedding ceremony or, similarly, of a Christening service makes a beautiful memento of the occasion.

These are really suitable opportunities to focus on formal calligraphy, with either Italic or Copperplate being the ideal scripts to use. The critical part is to make certain that the relationship of the various elements is just right. So again, be prepared to work at it and try various sizes and weights before making the final decisions.

Pay great attention to size and space. For an exemplar, I will focus on a Christmas menu. When you have the text formalised (make sure you get the cook/chef to agree the wording first), separate it into the various elements. My version, in **fig 93**, has Title, Toast, Appetiser, Roast, Pudding, Cheese and Reviver; seven elements in all, each separated by white space. Each course has its own subtitle heading and text. The subtitles are subtly emphasised simply by an increase in size; this emphasis could also be enhanced by colour and/or weight. However, do beware of adding too much emphasis. It is very easy to make the subtitles too big, too bold or too colourful. Keep the *just enough* concept, as was used for the spacing of words, lines, margins, etc., firmly in mind.

This 'just enough' motto will stand you in good stead in most of your calligraphy. As one of my early tutors was apt to say: *'Only add variables if absolutely necessary'*.

Christmas · Lunch

The Toast and Thanksgiving
Friends and family - Past and present
Mumm N·V champagne – Cordon Vert Tres Riches

The Appetiser
Ripe Honeydew Melon with Ginger

The Roast
Sirloin of Scotch Beef

Roast Maris Piper Potatoes –
– Fresh Cornish Cauliflower
Baked Parsnips and Carrot rings
A selection of mustards and horseradish sauce
to drink - vintage Rioja or Australian Chardonnay

The Christmas Pudding
flambéd with Armagnac
dressed with double Devon cream

The Cheeseboard Choice
Cornish Yarg · Devon Garland · Dorset Blue Vinny
to drink- Cotes des Beaumes de Venise

The Reviver
A brisk walk to Henlake Down on Dartmoor.

Fig. 93.

To return to my menu in **fig 93**, the main title was written with another nib size larger than the course subtitles. The nib chosen for the toast 'Friends and family – Past and present' was between the two. I think I would probably add a second colour to this line, as this is the sentiment of the occasion, and Christmas is, for most of us I imagine, the most sentimental of all family feasts.

Start making your menu by finding out which is the longest text line by a character count. Then write out this line to find the nib size needed to make it fit the available width with suitable margins. It will need to be reasonably small; menus are not posters, so start with something like a size 4 Mitchell, which worked well for me, or 1mm in Brause.

The next step is to write out all the 'text' lines with a bare minimum of line space. Then cut up the text into its various elements. Repeat the process with the subtitles (mine were written with a Mitchell 3). You can then arrange them by laying them all on a separate piece of paper and adjusting the space between the elements and subtitles. At this point you can try centred or left ranged layouts.

When you are happy with this spacing, the pieces of paper can be fixed with 'cow-gum' or a proprietary glue which allows for peeling off and further adjustment if desired.

Now you can test-write your main title (mine was done with a Mitchell 2); perhaps trying both capitals and minuscules, and place it in position. Then make your judgments about its size and consider the space around each of the elements.

Notice especially, in my exemplar, the careful use of a little extra space between the bottom line of each element and the title of the next one. The main title at the top has even more space to separate it from the first line of the toast. Finally, the margins are a little larger than the space under the title. In this manner I have ensured that the main text is separated from the edges of the background area, the title is kept away from the remainder, and lastly that, each element is given its own space.

When you are happy with the overall design (you have just

'made a plan' remember), it is time to transfer the result to a complete piece of layout paper. Lay a sheet over the paste-up rough and prick the vertical spacing measurements through, on a line down the centre. Then, with the aid of a 'T square' or the trammel of a drafting easel, rule the **base lines** of all the writing. Remember that these are only guidelines. They should be kept faint and lightly drawn. If you want to add a height line (to be sure of maintaining a regular letter size) it is best to make these measurements with a pair of dividers (like a compass but with two points). This is the only way to be certain that relevant lines are precisely the same height. You have to be careful, even with dividers, to get an accurate result. Take my word; it is impossible to do this accurately just using a ruler. Your text lines are only going to be about 4mm in 'x height', so real accuracy is essential. Finally, mark on this detail paper the start and finish of each line to ensure its being truly centred.

Now that you have a sheet of layout paper with all the necessary horizontal lines, and start/finish marks indicated thereon, you are ready to make sure that your ink is just the right consistency to be sure of getting good solid black marks on the thick strokes, together with fine hairlines to contrast with them. Should your paper seem a little greasy, try rubbing it lightly with a clean eraser. If the ink tends to spread into the paper at all, try dusting the paper with gum Sandarac powder. These measures should make a noticeable difference to the visual sharpness of your work. Other matters vital to best performance of pen, paper and ink can be found on pages 12, 14, 34 and 58.

This is the moment when, for the first time, you write out the whole piece on your detail paper. Then, stand back and take a good, hard, critical look at your work. Does the spacing need adjustment? Should the size of subtitles, etc., be altered?

Once you are satisfied with this stage, you can prepare and rule up a piece of the paper you want to use for your 'finished' piece. Trial and error will enable you to find the paper you like best. As noted in Chapter One, good quality cartridge paper of

about 100gsm (grams per square metre) is a suitable type with which to start or, if you really want to be certain of using excellent paper, try Saunders Waterford Hot Pressed hand made paper. This is favoured by most good calligraphers and is available in 190 and 300gsm weights from good art shops.

Almost inevitably, you will be tense when you start writing your 'finished piece'. Therefore, don't start at the top with the main title; write the text lines first, then the sub-titles and, finally, the main title. By then you will have got the feel of the paper/ink/pen working in harmony and, hopefully, you will have relaxed a bit and will produce your best possible result.

Consider this: **you will be as good as you are, at any given moment**. This is why you now need to 'go for it' and complete your finished piece, accepting inevitable minor blemishes that may occur as you write. Doing another 'practice sheet' will not make any real, noticeable improvement in the short term. On the other hand, by doing finished pieces of work, you will be practising doing finished pieces of work. In time you will get better at doing them. As Edward Johnston so logically remarked: *'practising makes you good at practising'*.

The use of the 'cut and paste' technique used to produce your 'rough' is, incidentally the standard method practised in most art and design occupations.

Certificate

We live in an age of qualifications; one in which most educational establishments issue each student with a professionally produced folder in which to collect the certificates, diplomas, etc., which he or she may gain during their education. Then there are the multitude of institutions, organisations, sports clubs, etc., all of whom make awards. Sadly, many of these certificates are design disasters with inappropriate typography, poor layout and the recipient's name scribbled in with a coloured felt-tip pen. That is not an exaggeration; it fairly describes an award from a major university on the wall of my

DIPTFORD·PRIMARY·SCHOOL

·this·is·to·certify·that·

has·carried·out·a·course·in·calligraphy
using·round·hand·and·italic·scripts
in·the·Summer·Term·of·199

Fig 94.

dentist's waiting room!

Thus there exists a plethora of opportunities for the calligrapher to design and produce – complete with names and dates – the pieces of paper which are presented.

Fig 94 shows a master copy of a course completion certificate: one that I did for a group of primary school children being taught the rudiments of calligraphy. It uses a script that the children learn, so it is directly relevant to them; it has capitals and minuscules, both of which they all attempted; and it uses rules (lines) to add emphasis in the manner of school exercises in writing. The children's names are added in a slightly larger size in a medium blue tone.

I make this point because relevance, or appropriateness, is a desirable requirement in most designs. Formal institutions like the gravitas and sophistication of Copperplate script, whereas a play school would be better served with something offering fun and frivolity. An engineering award would need something strong and mechanical. Probably typography would be most suitable for them but not so appropriate for the Royal Ballet School.

Again, in this project, the use of size and space are key design factors. During the cut and paste process try an upright (portrait) format. You may prefer it to the horizontal (landscape) style of my **fig 94**.

The main elements of this design are the title; the name (space for); and the text. The text is broken into three lines which state firstly, what has been done, secondly, the content of the course, and finally, when it was done. This split makes for a pleasant shape, with the text broken in the best possible places. This is an ideal to strive for, but one that is not always achievable.

Whilst it is conventional to design certificates in a formal, centred layout this is not essential. **Fig 95** shows an alternative, asymmetric, left ranged version for comparison.

Simple Book

Scholars have yet to agree as to what came first, inscriptions on

DIPTFORD
PARISH
PRIMARY
SCHOOL

This is to certify that

has carried out a course
in calligraphy using
round hand and italic scripts
in the Summer term of 199

signed Headteacher.

Fig 95.

stone, on baked clay tablets, or those in the form of written words on a scroll. For calligraphers, the important thing is that the initial use of a broad edged pen is most clearly seen in the book. The book, with pages made from vellum or parchment, was the successor to the scroll – which itself was originally made from papyrus (from which we get the word paper).

Truly to perceive what calligraphy is really about necessitates experiencing the making of a book. So, here goes . . . Books can be almost any size, from tiny little things whose only recommendation is the novelty of their size, to the huge Antiphonals – with covers made from oak boards studded with semi-precious stones – which were chained to lecterns in cathedrals for use by the whole choir. For our purposes let's start with something quite normal in size, which can be used as an exemplar for the process of designing, and writing, a simple calligraphic volume with a single gathering of pages.

Books are essentially personal things and, as such, they make wonderful presents for your loved ones. It is a great thrill to open a package and find a unique 'one off' book, made especially for you. It is guaranteed to soften the stoniest heart and win over the most reluctant misanthrope.

Nearly all of the conventions that you find in *this* printed book started life in the handwritten books of yesteryear. Firstly, there is the arrangement of the pages. When you open a book you have two pages on view. The righthand page is called the *recto* page, and the lefthand one the *verso* (which is the reverse of the previous recto). The top margin is called the *head margin*, the outside margins are *side margins*, and the gap between the two pages is the *gutter*. The most important pages, such as the title page, are always on the right (*recto*).

In my illustration **fig 96** can be seen a geometric method of creating a design for a page layout wherein the height of the text area is similar to the width of the page; and the ratio of the margins is 3:4:6 for the head, side, and bottom margins. As this is an ideal format, much admired in some of the best books from history, I will adopt it as my model on which to base this project.

Fig 96.

Take an A3 size piece of layout paper; fold it in half and crease it to form the gutter.

Guided by **fig 96** pencil in the diagonals of both single pages from top middle to bottom outside corners, and then those of the double opening, to cross the single page diagonals at A and B. From these points draw vertical lines to the top edge of both pages, and then draw the diagonals from these same points to meet the tops of the vertical lines (see broken lines in the diagram).

The intersections of the broken diagonals with the single page ones, labelled C and D, become the top inner corners of each text area. Draw the horizontal lines to meet the diagonals of the whole double opening at E and F, and from these points drop vertical lines to meet the single page diagonals at G and H. Drop verticals from C and D so as to meet the horizontal between G and H and thus find J and K.

Needless to say, all the construction lines should be drawn very lightly in pencil. Apart from the two rectangles, ECGJ and DFKH, all the other lines can then be erased

These rectangles create text areas which are in the same proportion as the page, and which have a very similar area to the remaining margins. This creates a harmony of both shape and size which is attractive to the eye and, the wonderful part is, that it works with any size and shape of page. It also has the great advantage (for the mathematically challenged) of not using any measurements.

Now that you have your basic page layout designed, the next part is to decide on the size of nib to use for your calligraphy. Unlike previous exercises, where you had the constraint of making the 'longest line' fit a given space, when you are dealing with continuous prose there are other factors to acknowledge. As mentioned earlier, in the section on line spacing in Chapter Three, the number of words to a line has a profound effect on the 'readability' of extensive blocks of text. Aim to select a nib to get between 6 and 9 words to a line. In **fig 97** I have used a Mitchell 3.

Another way of finding the right size nib is to write out the

In the beginning was the word and the word

Fig. 97.

alphabet so as to get something between one and a half to two alphabets on a line. This is 39–52 characters per line which, as the average word has six letters, approximates to 6–9 words per line.

After this you can find the number of lines which will fill the text area. Writing two lines with the correctly chosen nib will give you the minimum line space which allows sufficient space for ascenders/descenders. Write these lines. Then measure the separation between the two **base lines** with your dividers, and step off the base lines down the page.

It is highly unlikely that this will fill the space precisely. To achieve an exact fit, first mark the 'x height' (of your trial lines) below the top edge of the text area, see **fig 97**, so that the first base line is one letter height below the top edge. If, when you stepped them off, you found that 13 lines of text should comfortably fit the space, put the end of a ruler (where the measurements start) on the left end of the first baseline. Then find a convenient multiple of 12 (*note that you already have the first line, so you need 12 more lines*) on the ruler (I used the 24cm mark), and put this on the bottom line of the text area. This will probably be at an angle, and may be outside the edge of the area. As shown in my diagram, you can now mark down the ruler at 2cm intervals. This gives exactly the right number of lines to fill the space precisely.

Having found the accurate line separation, you can set the dividers to the exact measurement and prick through all your pages to mark both sides of the paper at once, thus ensuring that all the pages are set out identically at the same time. Now lightly pencil in your baselines. Those old scribes who developed these methods certainly knew how to work efficiently: they were probably on piecework!

Now you can work out how many pages you need. I suggest that you aim at no more than four pages of text. At eight words per line and thirteen lines per page you will have over 400 words. That's quite a lot of writing to do. However, this intensive practice will be very beneficial to your standard of calligraphy.

TITLE PAGE

using the same

layout

as the text page

in the book

by

⟶ JON·GIBBS ⟵

Fig 98.

When you have written your four pages of text, you can add a title page at the beginning and perhaps a colophon at the end. (A colophon is simply a short inscription, generally recording some interesting details about the making of the book and its author. See the end of this book.) The text area of the title page should be marked out using the same method as for the other pages. To ascertain appropriate sizes and weights for the title, subtitles and author's name, etc., use the same cut and paste process described earlier in this chapter under Menu. See **fig 98**.

This finishing touch will entail a further double opening. Thus the title occupies page 1. Page 2 (the verso of 1) may be blank or have a dedication page perhaps. Pages 3, 4, 5, 6 will contain the text; page 7 features the colophon; and the back page, 8, remains blank.

It is worth mentioning here that you will clarify things enormously for yourself by making a small scale mock-up of your book before proceeding further. For instance, you will discover that the first page of text (page 3) will be alongside page 6 – try it and find out.

Your book can also be wrapped in a cover, fashioned from heavier paper or card, of slightly larger dimensions than the inner pages. The whole thing can then be sewn through the spine with some decorative thread such as that used for embroidery. Bookbinding is a craft in its own right, and space precludes giving further ideas here. However, there are plenty of books which cover the craft in great detail if you want to extend your ability.

Decorative Map

Calligraphy and maps go hand in hand. Mercator, the famous 16th century map maker and geographer who invented a method of showing the spherical earth on a flat sheet of paper, was also a professional scribe who taught the Italic script to the literate people of the Low Countries.

The maps of John Speede, who published depictions of all the counties of the British Isles, are now collectors' items

Fig 99.

sought after at antique and book fairs, with their fine, flour-ished Italic script and heraldry. It is this decorative aspect that is the key to a handmade map.

To illustrate such decoration I have produced a useful, little map, see **fig 99**, to direct visitors to my house. The decoration includes a pen and ink drawing of the house, and makes a feature of some flourishing on the calligraphy. Maps are useful items, no matter how decorative, and they should be reasonably accurate even if not to scale. However, you do need to omit small details and any unnecessary information that would simply clutter up and detract from the visual effect. You will see from **fig 99** that I have, nonetheless, included some details which are not essential in order to effect a visual balance in the overall design.

A great many calligraphers are skilled artists as well, but a greater number are not and, if, like me, you find original drawing to be very demanding, then other means must suffice. You may well find that tracing from a photograph, and then altering the resulting drawing with the enlargement/reduction facility of a photocopier, is a practical way of getting a good result.

Really accomplished illustrators could try mapping their local town centre, adding drawings of prominent buildings and other attractions. Maps of sporting venues are also a rich source of opportunity. Think of the twin towers of Wembley Stadium, or the romance of details such as those found at the Royal and Ancient golf course at St Andrews, 'peopled' with the ghosts of past dramas of hope and despair, of reputations made and lost.

Needless to say, the 'cut and paste' technique is even more essential when there are illustrations to organise.

My aerial impression of the school playing field, in **fig 99**, points up the possibilities of something as simple as a 'garden plan', which perhaps you might also decorate with vignettes of the flowers contained therein.

Family Tree

Genealogy is growing ever more popular, with many retired couples making it their life's work to research, in as much detail as possible, the origins of their particular branch of the human family. In stately homes throughout the British Isles can be seen enormous framed documents going back to the year dot, replete with the colourful heraldic devices of some of the UK's most famous families.

My one hundredth exemplar is somewhat less ostentatious, and shows only the manner in which the basic layout is organised. As with most things it is possible to create versions in either landscape or portrait format. I have seen attractive designs within circular and diamond shapes; so try experimenting.

Given that each new human being has two parents (at least up to the present state of science) the number of one's forebears increases exponentially with each generation i.e. 2–4–8–16–32–64–128 . . . and this assumes a single child born to each union, which is a less than average progeny. This very quickly leads to a visually, and practically, unmanageable number of names with which to deal. For this reason, if none other, the pedigrees of ancient families tend to be restricted to the male line only. Our tradition of inheritance by primogeniture has reinforced this convenience.

Fig 100 shows (in the centre) one couple, Frank and Wendy Brady-Ramshaw, together with their siblings and children, and their own immediate ancestors back to their children's great grandparents. The two main surnames are written in capitals for emphasis, and I have followed the heraldic convention of having the male line on the dexter (right) side.

It is also conventional in family trees to ink the lines of descent in a colour, generally red. This in itself adds a decorative touch, to complement the flourished names in the title.

Animal lovers will understand that the very same methodology can be used for an animal's pedigree.

The Family Tree of

BRADY + RAMSHAW

Joshua BRADY
1800—1840
1st of 5 · 1m

married 1902

Sarah Williams
1870—1908
4th of 6 · 2m

William BRADY
1900—1962
1st of 2m

married 1929

Zachary Smith
1857—1933
4th of 8 · 6m

Mary Smith
1911—1981
2nd of 2 · 1m

married 1900

Mary Bell
1858—1911
3rd of 7 · 3m

Frank BRADY
b.18·3·32
2nd of 3 · 1m

Kathleen
b.24·8·30

Doreen
b.18·12·34

married
24·June·1960

Simon Mark
b.10·2·66

Charlotte Mary
b.1·4·68

Francis William
b.29·9·71

Wendy RAMSHAW
b.23·2·70
1st of 2 · f

Sheila
b.16·4·43

Albert RAMSHAW
1890—1908
2nd of 2m

married 1920

Susan Bletchly
1895—1978
3rd of 3 · 1m

Elijah RAMSHAW
1860—1915
2nd of 8 · 3m

married 1883

Emily Bates
1865—1960
1st of 2 · f

Freak Bletchly
1855—1905
4th of 6 · 3m

married 1895

Emily Shaw
1850—1940
3rd of 3 · 2m

Fig 100.

Poem

Poetry is a medium which almost all calligraphers explore sooner or later. Unfortunately, it is also the medium which is most abused by calligraphers. So perhaps a few words about the philosophy of the relationship betwixt the two will not go amiss.

Poetry has been described as *the best possible words, in the best possible order*. Wheresoever this is true, then it ill behoves the scribe to do anything other than enhance the text. There has long been a dialogue between poets and calligraphers as to what is acceptable in this context. Some poets insist that conventional text typography is the only proper medium for their work; others are quite happy for the calligrapher to add his/her artistic interpretation. I think that the best advice I can offer, about any adornments, is —

- if in doubt, **don't**
- avoid **literal** illustration (e.g. words like 'frozen' with snow atop the letters)
- be sensitive to the **meaning** of the text.

Edward Johnston was once asked for a Christmas message for his students; he replied *'be true to the words'*. I can't improve on that.

The poem that I have chosen as an example for you to interpret in your own way is 'Thaw' by Edward Thomas, see **fig 101.** Thomas is a poet with a great feeling for the English landscape and, like all good poets, he gives the reader a unique insight into his subject matter. As I write this we have just had a dramatic snowfall in England's West Country and, with equal suddenness, it has thawed overnight. At last midnight the landscape was white. This morning the snow had virtually disappeared, just as if some omnipotent presence had waved a magic wand. I think Thomas had a slower thaw in mind when he wrote this serene poem:

> *Over the land freckled with snow half-thawed*
> *The speculating rooks at their nests cawed*
> *And saw from elm-tops, delicate as flower of grass*
> *What we below could not see, Winter pass.*

Immediately, as I absorb his words, I have a picture in my mind of the bird's eye view, seen in black and white from on high. The phrase 'delicate as flower of grass' describes exactly the twigs on the furthermost tips of the leafless branches. And I am given a sense of things unclear, half hidden, perhaps a little misty, in the phrase 'what we below could not see', and then of the quiet finality of the last two words 'Winter pass'.

This analysis, more intuitively felt, rather than intellectually dissected, gives me the clues I need for my interpretation – namely the use of black ink on white paper, in parts thinned to give greys; enhanced by a combination of light and heavy weight scripts and a tall thin layout; being careful only to break lines at the separation of phrases so as not to spoil the meaning of these beautiful words.

Now is a time for you to experiment with your own version. Different weights, sizes, tones, scripts, capitals, or minuscules, even texture of paper can all play a part because, even with talent, we rarely – any of us – manage to 'think' our way direct to a final resolution. You have to do a trial, cut it up, paste it back together again, move things about, change tones. Of one thing you may be sure – the more you experiment the more likely you are to get a good result.

Don't skimp yourself for paper; if an idea doesn't work, scrap it and start again. Try covering up part of the text with tissue paper or tracing paper, to get that sense of things being half hidden. Try splashing diluted ink onto the paper, and then blot some of it. Make a mess. It doesn't matter.

Gradually it starts to look right, and you think 'Isn't calligraphy terrific?'

My example was written on normal cartridge paper, in black ink which had been diluted to give a translucent effect. The writing was blotted line by line with screwed up paper tissue to make it deliberately blotchy, and this was enhanced by dabbing on some grey gouache with a small piece of natural sponge. The phrase 'delicate as flower of grass' was written in opaque ink with a fine nib (a Mitchell 4½) and the ascenders decorated to give a sense of the meaning of the words. The title word

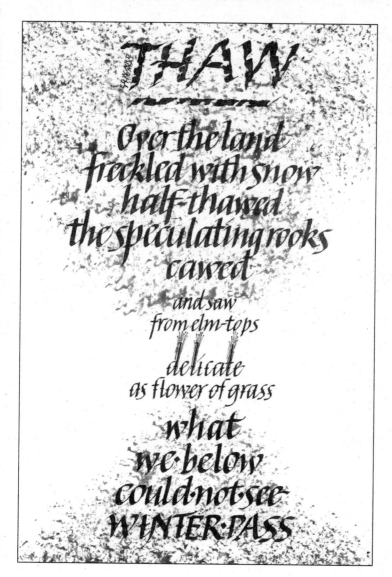

Fig 101.

5

CALLIGRAPHY FOR REPRODUCTION

Several of the projects described in the previous chapter might need to be reproduced in quantity for practical purposes. I intend now to help you produce the original in the best manner, and then to discuss the merits of the more common forms of printing/reproduction, so that you will be able to make an informed choice.

First, let me digress for a few words about the difference between calligraphy as a unique 'one off' piece of artwork, which you might want to have framed, etc., and work done specifically for reproduction. *'Calligraphy is theatre'.* You learn your lines; you rehearse to combine the various elements and to get the interpretation sorted properly. These are the experimental, practice pieces. Then there is a dress rehearsal, with the orchestra, etc. This equates to the final rough; done on the same surface to be used for the finished piece.

On your opening night, however, you have to give a *complete* performance, warts and all. If you make a mistake you just have to continue until the piece is finished.

This is why I insisted on your making finished pieces of work early in your introduction to the craft. It's the only way of getting better at the final performance!

Working on calligraphy for reproduction is more like making a film. You make the parts separately. A single word may be written out 10 or 20 times, and then the best version is chosen. Even then, adjustments can be made with the use of

artists' process white to blot out errors, and corrections added after. Finally, only when you, the designer, are satisfied with all the parts, they can be pasted up into the final design and sent to the printer.

This process of correction, refinement, alteration, scraping off, cutting out, pasting up, etc., **is not cheating**. It is the professional, efficient and economical way of getting the best possible result. If you are going to produce hundreds maybe thousands of copies, the time and effort spent on the artwork is worthwhile.

'One off' calligraphy is human, lively, vital. It has the inevitable imperfections of a living being; whereas lettering for reproduction is highly finished, refined and virtually perfect; like a classical Greek statue in white marble. The two things are, of course, similar; yet they are also, essentially, different.

Reproduction methods have increased enormously in both variety and quality, in recent years.

Photocopying is now available in both black and white and colour, on a wide variety of surfaces (even tee shirts). You can specify enlargement or reduction from your original. For small quantities it is also the most economic. If you want 50 certificates for, say, a school sports day, this is the method. However, unless you can afford the expense of full colour copying, it is not really practical to have more than a single colour. Your artwork can, however, be copied onto coloured papers which can be a useful and attractive alternative.

Photo Lithography is a recognised, professional printing technology whereby the printer will make a printing plate from your original artwork, and then print whatever quantity you order. Making the photographic plate costs money but, after that, the more copies you order the cheaper is the unit cost. This is not really economic for less than a hundred. If you want more than one colour, you will have to give the printer separate artwork for each colour and, as he will have to make a separate plate for each colour, the cost increases accordingly.

All your artwork should be supplied in black on white. (However, whilst mentioning this, I should explain that the printer can reverse tones for you, which is how you can achieve light lettering on a dark ground.) As with any form of printing, it is wise to discuss your needs with the printer before commencing the project.

Digital Printing is the technology of today and tomorrow. Your artwork is/will be scanned into a computer (either in colour or black and white) and then printed, either via a laser printer, or an ink jet printer, depending on the level of quality you need. The possibilities for image manipulation/refinement/correction are almost limitless; talk to your printer to find out about the details of what he can offer.

Screen printing is a technique that can be economic especially for large size items such as posters. As with litho, each colour needs separate artwork. It is applicable to almost any surface, even three dimensional ones such as beer bottles!

Enlarging and Reducing

Below you will find a number of generalities that need to be taken into account when designing and producing artwork for reproduction.

The quality of the finished, printed item **decreases with every separate process**, see **fig 102**. Here, for example, I have photocopied a word several times, each time from the print made previously. This explains why colour slides are sharper and have a wider range of tones than colour photographs. With photographs there is an intermediate processing stage, the negative. Slides are made directly from the film in your camera.

Enlargement gives poorer quality. Reduction normally improves quality, see **fig 103**. Here, I have written the same word both large and small, and then enlarged and reduced them.

Normal professional practice is to produce original artwork oversize (generally 150-200% larger). The printer will then reduce your original to the desired size on his PMT camera,

Reproduction ¹

Reproduction ²

Reproduction ³

Reproduction ⁴

Reproduction ⁵

Fig 102.

Reduced

Enlarged

Fig 103.

Enlarged

Reduced

Reduced

Enlarged

Fig 104.

before he makes his litho plate from the PMT print. The increase in quality gained by reduction offsets the fact that there are two intermediate stages in this process. In this way a good litho print should be as sharp as possible. Indeed, minor imperfections on your oversize original may well disappear. As digital scanning is increasingly replacing the older technologies, presentation of artwork may need further refinements still. Always check with your printer first.

Printers work on oversize paper. Therefore your artwork must have trim marks to indicate where the edge of the image is intended to be. These are normally given as crosses at each corner, and are best done with a fine technical drawing pen to ensure accuracy. The designer's responsibility includes ensuring that trim marks are both accurate and square, see **figs 104** and **106**, so that when the printer guillotines the finished product down to size, it will be exactly as required.

Printing quality from artwork that is scanned into a computer is dependent on the relevant technology. Professional quality machines work at very high resolutions, as do the laser printers, and so they will give first class results. The home personal computer/scanner/printer set up, being much cheaper initially, cannot be expected to produce professional quality but it is getting better all the time and sometimes offers surprisingly good results.

Letterhead

A well printed piece of calligraphy on some good quality paper, such as 'Conqueror', makes for a very pleasant letterhead for personal or business usage. The use of a second colour (or a tint of a single colour, which will be explained later) gives a more professional appearance. The process is as follows.

Let's assume that your letterhead for business use will be on A4 size paper (this size is almost universal today) and that the text is John Smith, Calligraphy, 123 High Street, Newtown, AB2 4XZ. Telephone 0123 456789. First, comes the design process of trying alternatives – what style, size, weight, colour, etc. I have decided that, for the purposes of this book, mine will

be in black and grey on white paper, using calligraphy for the name and occupation, and typography for the address and telephone number. Most printers will produce the typography for you if you don't have access to a personal computer/word processor from which it can be gained.

The typography, incidentally, emphasises the handwritten nature of the calligraphy, and is also more practical if you want to maintain readability after reduction for printing. In that process, to remind you, lies the reason why I would work on A3 size paper – so that the image should be sharper when it is, ultimately, reduced down to A4 for final printing.

It is worth being aware how the 'A' system of paper sizes comes about.The largest A size is A0 which measures 1189mm by 841mm; the area of which, for practical purpose is one square metre. This may seem an irrational size, but is actually a very useful one. Its proportion is $1:\sqrt{2}$. This important fact means that each time you fold the paper in half across its long edge you create the next size smaller which, by definition, is in exactly the same proportion, see **fig 105**. Thus, from one sheet of A0 you get two of A1, four of A2, eight of A3, etc.

The first step towards creating your own letterhead is to write out your name and occupation, in your desired style, using opaque black ink on standard cartridge paper, **at a letter size which looks correct** on A3 paper. Next add the typography; the address and telephone number – again at a size which is correct on A3. (The sizing of type is an arcane subject, outside the scope of this book. Be guided by your printer, who will have a variety of typefaces from which to choose, as to a suitable size and style.) Remember to use the 'cut and paste' technique as previously described.

The next step is to have your artwork reduced to 71% of its original size. This is the transition from A3 to A4 size. Depending on your local facilities, you may have this done on a top quality photocopier or, better still, on a PMT camera. After this you will need to separate any colours/tones so that you can present to the printer separate pieces of artwork for each colour. On my letterhead, shown in **fig 106**, one piece has

Fig. 105.

John Smith
Calligraphy

123 HIGH STREET NEWTOWN AB2 4XZ TEL 0123 456789

Fig 106.

the calligraphic name and the typography on it, and the other has just the word 'Calligraphy'. This way I can have the two parts printed in different colours, rather than just in black and a grey tone as it has to be in this book.

These colour separations (as they are known) should be mounted on a surface which has a 25mm margin *outside* the A4 trim marks. The base should be either heavyweight paper or thin card; this prevents distortion whilst the plates are being made.

It is vital that every image or line, on all your artwork, is accurately set out to be truly horizontal/vertical on the surface relative to the trim marks. These marks, which control the position of every aspect of the artwork being reproduced, must, naturally, be identically placed on all the individually separated pieces from the outset. You can make sure of this precise registration by pricking them through onto each finished artwork sheet. Only if this work is done precisely will the two pieces of artwork align and register perfectly, when both are printed on the final surface. Remember that it is the designer's responsibility to ensure accuracy, as well as the printer's.

In a professional studio, the lining up of artwork is carried out on a light box, using transparent set squares, etc. You can manage without such facilities, but you do have to be extra careful to avoid errors. Bear in mind that your artwork is not the finished product. You can always cover unwanted marks with process white, or correct mistakes simply by scraping part of the artwork and pasting in a new piece of paper with a rewritten example on it.

A word is needed here about colours and tones. Your printer will have samples of papers, and ink colour swatches, to enable you to choose with discrimination the combination that will look 'just right'.

You can achieve a sense of two colours by specifying a 'percentage tone' for part of your artwork. In this way you get two 'colours' for the price of one, as the printer only uses one printing plate for that colour. This small bit of magic is achieved during the plate making process, by putting a 'screen' over the

area that is to be printed lighter. This allows the paper to show through to a specified amount, see **fig 107.** A 10% screen gives a very pale tone and 90% one of almost solid colour. This technique can equally be reproduced on digitised artwork via a computer. My illustration, which shows a limited range of tones, is sourced from such a machine.

If colour is going to be really critical, ask for a proof (trial) copy. Then you will see how that colour looks printed on the paper stock that you have chosen. Even this is not absolutely fool proof, as the machine may well print 'thinner' when running at normal speeds. However, this does minimise the possibility of your being disappointed by the result. Never rely

Fig 107.

on computer screen colours; colours always look different when printed – always!

Logotype

Uniquely crafted initials or whole names used to be known as trademarks, and some of the early ones such as 'Ford', 'Coca Cola', 'ICI', etc., have become part of our visual heritage. Now known as 'logos', they seem to be an essential part of the business scene, with multi-national companies spending tens of thousands of pounds on their design.

Without going into the nuances of corporate identity, the primary requirement is that a logo should be distinctive and easily identifiable. An effective way of achieving this is to make a pattern, either from an initial letter, or from the whole name; or even to use a combination of both. In **fig 108** I have used this method to create an alternative 'Right Way' logo for the publishers of this book.

A letter may be seen to have four faces, either by rotating it through 90 degrees or by 'flipping' it through a mirror image both vertically and laterally. Such devices can be linked to geometric shapes which are inherently eye catching. Also they can be enhanced by the judicious use of tones and reversed letters (see page 193) as I have done here.

Another way of adding interest is to introduce a contrast in weight and style of the letters, so as to make the whole image visually exciting. My examples have been produced on a personal computer, to enable a variety of alternatives to be made quickly and conveniently. After getting the image that I felt worked best – the four faces of 'R' in a square, I added the whole name of the publisher to form a frame.

Obviously typography, in this instance, is more suited to a publishing company. However, in a more suitable context the image could be made with pens and/or brushes.

Wine Labels

Home made wine and beer offers you opportunities to put your

Fig 108.

skills to work in a practical and attractive way. A quick perusal along the shelves in your local supermarket or wine merchant will give clues as to the nature of designs that are appropriate, or, perhaps, simply relevant to the country of origin of the wine/grape variety – such as Gothic script for German types, Italic for those from Italian vineyards, etc.

Now that much wine originates from countries/regions that have no particular calligraphic connotations, the way is open for almost any type of creative lettering. The advertising by one major United Kingdom wine merchant, using the wonderfully quirky script of that superb illustrator, Ralph Steadman, points to the endless possibilities open to the creative scribe. In **fig 109** I have shown some possible combinations of letterforms suitable to the places whence some well known varieties are made.

Expressive Lettering

This subject will conclude my introduction to practical calligraphy for reproduction. It follows very easily from the making of wine labels, which are a perfect opportunity to use this type of work. First, however, I offer a few thoughts about the history and background of it.

For around 1500 years – as I wrote in Chapter One – calligraphy was normally made with a broad edged pen. The nibs of these pens give a logical pattern of thick and thin strokes. In the 17th century the pointed pen took over to become the norm, and continued to be the most popular writing implement for both formal and informal use until the invention of the typewriter. From then on it became unnecessary for most commercial writers (clerks) to have good handwriting.

During the 19th century, when the Industrial Revolution was in full swing, the practice of advertising goods and services came into being. At this point the concept of 'good letters' gave way to that of 'effective letters'; that is, lettering which served a purpose.

There was, unsurprisingly, soon to be a backlash against the rampant commercial and industrial practices of the period.

Chardonnay

Jacob's Creek

Rioja

Champagne

Burgundy

Chianti

Riesling

Fig 109.

This became recognised as the 'Arts and Crafts' movement, and part of it was a revival of broad pen calligraphy through the teaching and writing of Edward Johnston. This calligraphy was essentially formal in context, exemplified in the making of rolls of honour, and the crafting of manuscripts of fine literature.

Pointed Brush

However, parallel to this, was the growing practice of 'commercial art' being done by artists in whose studios were produced the advertisements for, and packaging of, almost every type of product. The leaders of this form of lettering were mainly to be found in the USA, and these lettering artists largely favoured the use of the brush rather than the pen. Their aim was to create a letterform which '*expressed*' the nature of the goods on offer, or the ambience and atmosphere that the manufacturer wanted to associate with his product.

An advertisement or label for a perfume might need to be sophisticated, or sexy, or elegant, or simply fresh. A pointed brush, in the hands of a skilled and imaginative commercial artist, could satisfy all these demands. But what if you wanted to sell dumper trucks, or funerals, or jewellery, etc.? As you may imagine the opportunities were endless.

Then, in the late 1950's, along came 'Letraset', a form of lettering that was available to anyone, with or without skill, that could provide highly professional results.

In the same way that the scribes of the 15th century became teachers when the advent of printing made them redundant, so lettering artists of the 1950's and 60's moved on to designing the alphabets produced by the makers of 'rub down' lettering. Now we see them producing the alphabets that are available for the personal computer. It's called progress, so I believe!

Meanwhile, in Germany, a few calligraphers who preferred the use of the pen, started to adapt their pens to produce non-traditional results. This spirit of experimentation has crossed continents and now, throughout the Western hemisphere, scribes and artists are making letters with virtually anything

that will make a mark. As if that were not enough, they can also scan them into a personal computer and further manipulate the final appearance; so much so that, in a recent issue of a magazine devoted to typography and lettering, could be seen 'pictures' made from up to 40 layers of images of letters.

The main type of brush that calligraphers use is the normal, pointed, artists' watercolour brush. Those made of synthetic fibres have the requisite amount of spring which is necessary for most lettering work; however, almost any kind of brush can be pressed into service as the occasion demands.

Automatic Pen

For those of you who want to experiment, a good place to start lies in the use of the so called 'automatic pen', see **fig 110**. This British-made product is an extremely versatile tool. In its simple form, as shown in my illustration, it is available in widths from 5mm to 40mm, which makes it ideal for posters and other large scale uses. Its unique construction allows the use of almost any kind of ink, paint, etc. The metal of the 'nib' is quite

Fig 110.

soft. This means it can be filed into other shapes, which makes
it so adaptable as to be invaluable to most letterers. There are
also a number of versions which allow multi-line strokes to be
made, such as the one which I used to write the word 'musick'
for **fig 111**.

Fig 111.

Fig 112.

Ruling Pen

Another type of pen, much loved by contemporary calligraphers, is the old fashioned bowspring 'ruling pen' which is normally used by draughtsmen for drawing plans. This also allows for a great variety of unusual effects.

Miscellaneous Tools

In my final illustrations, **figs 112**, **113**, **114**, can be seen some examples of letters and lettering made with a variety of tools (not necessarily pens or brushes). I leave you to guess as to what made which, not because I want to keep it a secret, but because I believe that the real fun and satisfaction, when you get to this stage, lies in the experimentation (I rather think of it as playing) with all sorts of tools.

The journey starts with very formal disciplines of pen angle and historical models, and ends with total freedom, where there is no 'right or wrong' but simply lettering that works. Just as walking leads to running and then to dance; you still have to learn to walk first, but it's great fun.

Fig 113.

Fig 114.

APPENDIX
Useful Addresses

Materials
Falkiners Fine Papers 76 Southampton Row, London. WC1B 4AR

Mail order service for everything the calligrapher needs.

Cornelisons 105 Great Russell Street, London. WC1B 3RY

An Aladdin's cave of materials and equipment for all kinds of artists and craftsmen.

Philip Poole (has space within Cornelisons shop)

A specialist supplier of all things essential for Copperplate calligraphy. His shop includes a mini museum of pens and nibs dating from the 18th/19th centuries.

Societies
Calligraphy & Lettering Arts Society (CLAS) 54 Boileau Road, London. SE13 9BL

Founded specifically to cater for the amateur calligrapher. Good programme of events, exhibitions and courses, etc. Publishes a useful journal called 'The Edge'. Will also put you in touch with your local society.

Society of Scribes & Illuminators (SSI) 6 Queen Square, London. WC1N 3AR

Founded in 1921 by the students of Edward Johnston to foster calligraphy at the highest level. Its Fellowship award is the highest (and toughest) accolade that any calligrapher can achieve. Publishes a quarterly magazine called 'The Scribe', with interesting features and fine illustrations.

Museums
The British Museum Great Russell Street, London. WC1B 3DD

Here is to be seen a world famous collection of manuscripts of every period and style from earliest times to 20th century, including those of other cultures such as Islamic, Oriental, etc. Good bookshop.

The Victoria & Albert Museum Cromwell Road, Kensington, London. SW7 2RL

Houses the 'National Art Library' with its unrivalled collection of modern manuscripts. No permanent display; therefore you need a 'reader's ticket' to view them.

Courses
Roehampton Inst. of Higher Education Roehampton Lane, London. SW15 5PH

BA Hons degree in Calligraphy/Bookbinding.

Reigate School of Art & Design Blackborough Road, Reigate, Surrey. RH2 7DE

Higher National Diploma in Lettering & Calligraphy.

Plymouth College of Art & Design Tavistock Place, Plymouth, Devon. PL4 8AT

National Diploma in Signwork and Creative Lettering.

West Dean College Singleton, nr Chichester, Sussex. PO18 0QZ

Short courses in all the lettering arts and crafts.

Having taught at all the above colleges I can recommend them for the person who aspires to reach the best possible standards. There are also signwriting and lettering courses in a great number of Further Education Colleges. Your local library will have directories.

BIBLIOGRAPHY

There are a great number of books which focus on different aspects of calligraphy and/or lettering. The following are standard reference works:

The Calligrapher's Handbook – Black. Edited by the late Heather Child FSSI.
A mine of useful information on specialist aspects such as gilding, vellum, etc.

Historical Scripts – Black. Written by Stan Knight FSSI.
The standard work on formal scripts, with excellent illustrations.

The Story of Writing – Studio Vista. Written by Donald Jackson FSSI.
A very readable book on the evolution of Western calligraphy and lettering by the finest all round scribe in the UK. There are also 4 videos which have been shown a number of times on BBC TV.

Creative Lettering – Bodley Head. Compiled by Michael Harvey (internationally renowned lettering artist). A compendium of Michael's four previous books, covers the whole spectrum from calligraphy to digital typography.

Lettercutting in Stone – Anthony Nelson. Written/illustrated by Richard Grasby.
Superb 'how to do it' book on this fascinating craft by an acknowledged master.

Scribes and Illuminators – British Museum Press. By Christopher de Hamel.
One of a series on medieval craftsmen; a wonderful insight into what life was like for the people who wrote the superb MSS to be seen in the museum.

The Lefthanded Calligrapher
This was published a few years ago and may be available through your local library. It has a few useful hints for those who are left handed but, I am advised by my colleagues who are similarly affected (or is it afflicted?), that there are no easy answers. Our alphabet was evolved by right handed scribes; it can be written well by the left handed. However, I am told that each person has to work out their own solution.

COLOPHON
Thanks and Acknowledgements

In 1996, having decided to resign my teaching post, I was looking to resolve two problems. Firstly, I wanted to continue to pass on my accumulated experience and, secondly, I wanted to buy an Apple Macintosh personal computer.

Along came my Fairy Godmother, in the unlikely guise of Malcolm Elliot, who wanted to publish a 'how-to-do-it' book on calligraphy. Perfect symmetry – I would need a computer to write a book; which in turn justified buying a Mac – the circle was squared.

So my first big thank you goes to Malcolm, for having the initial idea, but also for his great expertise as an editor and publisher (and as a part time English teacher).

It was the late Maurice Percival (the former Art Master of Harrow School) who fired my initial interest in calligraphy by introducing me to the work of the greats of twentieth century British calligraphy, such as Edward Johnston and Irene Wellington, via the V & A Travelling Exhibition. He also directed me to the classes at the Hampstead Institute, taught by Ann Hechle.

Ann gave me so much, notably her great understanding of the art, craft and technology of fine writing. But also she passed on her deep love and enthusiasm for words from a myriad of sources.

Donald Jackson changed my life by suggesting that I take up teaching: I hope I justified his confidence.

Brian Rhodes offered me my first full time teaching post but, more importantly, was the superb role model on whom I

based my professional practice. Similarly, Bill Stewart and the late John Windsor were inspirational mentors.

Last, but not least, my heart-felt thanks go to all those students who, besides keeping me in gainful and enjoyable employment for so long, provided the motivation to rethink everything in the constant search for excellence – as well as the challenge continually to refine and develop the means of passing it on.

It has been said *'to teach once is to learn twice'*. Now I would add, *'to write a book is to reconsider your whole philosophy'*.

Let me leave you with this final quote from the master – Edward Johnston, *'Our aim should be to make letters live, that man may have more life'*. A truly beautiful sentiment.

INDEX

RIGHT WAY
PUBLISHING POLICY

HOW WE SELECT TITLES

RIGHT WAY consider carefully every deserving manuscript. Where an author is an authority on his subject but an inexperienced writer, we provide first-class editorial help. The standards we set make sure that every **RIGHT WAY** book is practical, easy to understand, concise, informative and delightful to read. Our specialist artists are skilled at creating simple illustrations which augment the text wherever necessary.

CONSISTENT QUALITY

At every reprint our books are updated where appropriate, giving our authors the opportunity to include new information.

FAST DELIVERY

We sell **RIGHT WAY** books to the best bookshops throughout the world. It may be that your bookseller has run out of stock of a particular title. If so, he can order more from us at any time – we have a fine reputation for "same day" despatch, and we supply any order, however small (even a single copy), to any bookseller who has an account with us. We prefer you to buy from your bookseller, as this reminds him of the strong underlying public demand for **RIGHT WAY** books. Readers who live in remote places, or who are house-bound, or whose local bookseller is unco-operative, can order direct from us by post.

FREE

If you would like an up-to-date list of all **RIGHT WAY** titles currently available, send a stamped self-addressed envelope to
ELLIOT RIGHT WAY BOOKS, BRIGHTON ROAD.,
LOWER KINGSWOOD, TADWORTH, SURREY, KT20 6TD,U.K.
or visit our web site at www.right-way.co.uk